National Gallery of Scotland
Edinburgh

16 October–13 December 1981

Poussin Sacraments and Bacchanals

Paintings and drawings on sacred and profane themes
by Nicolas Poussin 1594–1665

D1386201

Published by the Trustees of the National Galleries of Scotland

Copyright © 1981 National Galleries of Scotland

First edition 1981
Published by
The National Galleries of Scotland
The Mound
Edinburgh EH2 2EL

ISBN 0 903148 38 2

Designed by Herbert and Mafalda Spencer
Made and printed in Great Britain
by Lund Humphries, Bradford, Yorkshire

Front cover: *Confirmation* (no.35)

Back cover:
Self-portrait (no.56)

Contents

Foreword

In a few rare instances, great painters leave behind them unusually clear traces of the way their ideas developed, and these instances must count with the most precious evidence of our culture. One thinks of Rembrandt's series of self-portraits or Cézanne's views of the Montagne Sainte-Victoire. None is more revealing or more deeply moving in its way than Poussin's two heroic series on the theme of the sacraments and the drawings that he made in working out their designs. This is the first time the two series have ever been seen together.

We have sought to illuminate the occasion by extending the exhibition in two directions. The other side of Poussin's art is represented by the Bacchanals he painted for Cardinal Richelieu and other paintings and drawings related to them. They show the Dionysiac beside the sacred or, as Poussin might have said, the Phrygian beside the Dorian mode. But these Sacraments and Bacchanals are among the most sophisticated paintings in the European tradition, and we have assembled a group of Poussin's earlier works to show the direction in which his ideas about painting had been moving.

This ambitious project could not have been realized at all without the support of several people. Our gratitude goes first to the Duke of Sutherland, who has allowed the second series of the Sacraments to remain with us as part of his priceless loan to Edinburgh since 1946, and to the Duke of Rutland who responded warmly to our project and agreed to allow all his five paintings from the first series to come from Belvoir Castle. The key work from the Richelieu Bacchanals is *The Triumph of Pan* from Sudeley Castle. It was specially cleaned for the exhibition by our Restorer John Dick, with John Brealey, Chief Restorer to the Metropolitan Museum New York, acting as consultant. We owe special thanks to Lady Ashcombe for making this loan possible and to John Brealey for giving his time and expert advice.

We wish to thank Her Majesty The Queen for graciously allowing us to show a superb group of Poussin drawings from Windsor Castle. The response of owners to our requests for loans was extremely generous and

we owe special thanks to our colleagues: Hamish Miles, The Barber Institute of Fine Arts, Birmingham; Peter Day and the Trustees of the Chatsworth Settlement; Louise S. Richards, Cleveland Museum of Art; Homan Potterton, National Gallery of Ireland, Dublin; Giles Waterfield, the Dulwich Picture Gallery; Anna Maria Petrioli Tofani, Gabinetto Disegni e Stampe degli Uffizi, Florence; Ralph T. Coe, Nelson Gallery–Atkins Museum, Kansas City; J. A. Gere, Department of Prints and Drawings, the British Museum; Sir Michael Levey, the National Gallery, London; Alfonso E. Pérez Sánchez, the Prado, Madrid; Xavier Dejean, Musée Fabre, Montpellier; Annie Jacques, Ecole des Beaux-Arts, Paris; Jean Sutherland Boggs, Philadelphia Museum of Art; Michel Laclotte, Département des Peintures, the Louvre; Maurice Sérullaz, Cabinet des Dessins, the Louvre; and J. Carter Brown, the National Gallery of Art, Washington. We do not forget that the most important of the early paintings here is *The Mystic Marriage of St Catherine,* the magnificent bequest of Sir John Heathcoat Amory to Edinburgh in 1973.

The cost of mounting an undertaking on this scale has now become very considerable, and we gratefully acknowledge the generous financial support we have received towards the publication of the catalogue from the Carnegie Trust for the Universities of Scotland, Occidental International Oil Inc. and the Scottish International Education Trust. The Carnegie Trust also gave a grant to Hugh Brigstocke for study in the United States in connection with the exhibition. Our thanks are also due to the Association Française d'Action Artistique, for a generous contribution towards the cost of bringing the Paris loans to Edinburgh.

Colin Thompson
Director, National Galleries of Scotland

Preface

In preparing this exhibition we are deeply conscious of our debt to those who have made Poussin their particular study. The work of Anthony Blunt is obviously indispensable to any project associated with the artist and a casual glance at this catalogue will reveal how heavily we have depended on it. Of the younger generation of specialists Richard Verdi and Claire Pace have given unstintingly of their knowledge and advice, especially in the choice of quotations from the historical literature on Poussin which we have included. We should also like to thank Professor Blunt, Pierre Rosenberg, and Clovis Whitfield for help at various times.

The essays and entries on the paintings (HB) and drawings (HM) are our individual contributions to the catalogue, which is otherwise a collaborative effort. We are pleased to include the essay on the iconography of the Sacraments which Nicholas Gendle was invited to contribute; and we are grateful to our colleague John Dick for his technical notes on these pictures. Bibliographical references are kept to a minimum although it is appropriate to state here how much we have learnt from the catalogue (unaccountably omitted from the Poussin literature) which Ralph Holland prepared for the exhibition at the Hatton Gallery, Newcastle upon Tyne (1951/2) to which the Duke of Sutherland lent his Sacraments. The quotations from Poussin's letters and the Chantelou journal, in Christopher Cornford's translation, are reproduced here by his kind permission. The reproductions of both sets of Sacraments (excepting the Washington *Baptism*) are taken from photographs made by Michael Dudley of the Ashmolean Museum, Oxford.

For assistance freely given by colleagues in this country and abroad which far exceeded the limits of duty imposed on them as institutional lenders we mention here:

Elizabeth Churchyard and Michael Wilson, National Gallery, London; Stephen G. Rees-Jones, Courtauld Institute, London; the Hon. Mrs Roberts, the Royal Library, Windsor Castle; Geneviève Monnier and Elizabeth Walter, the Louvre, Paris; Manuela B. Mena Marqués, the Prado, Madrid; Joseph Rishel, Philadelphia Museum; Anne Heonigswald and

David Rust of the National Gallery of Art, Washington. Finally, we are grateful to Ralph Holland who advised on the reconstruction of Poussin's model stage which was made by members of the Department of Fine Art at Newcastle University, in particular by Andrew MacLaren and Jonah Jones.

Hugh Macandrew
Keeper

Hugh Brigstocke
Assistant Keeper

Biographical note

(?) 1594	Nicolas Poussin born near Les Andelys, Normandy.
1611–12	Quentin Varin, a minor painter worked at Les Andelys and confirmed the young Poussin in his vocation.
1612	Went to Paris by way of Rouen, where he may have been apprenticed to the painter, Noël Jouvenet.
1612–21	Poussin's formative years, spent mostly in Paris under various masters. Studied the prints of Raphael and Giulio Romano and gained access to the classical sculptures and Italian paintings in the Royal Collection.
1622–3	Met the Italian poet G. B. Marino for whom he made drawings for his poem *Adone* and the *Metamorphoses* of Ovid (see no. 58). Painted a *Death of the Virgin* for Notre-Dame, Paris (see no. 57). Employed at the Palais du Luxembourg, Paris under Nicolas Duchesne.
1624	Arrived in Rome by way of Venice, where he may have stayed for some months.
1625–6	Years of great hardship for Poussin. Studied anatomy, optics and perspective; drew and measured classical sculptures. Studied Raphael, Giulio Romano and particularly Titian's Este *Bacchanals,* then divided between the Villa Aldobrandini (see no. 6) and the Ludovisi collection.
1627	Painted the *Death of Germanicus* (Minneapolis) for Cardinal Francesco Barberini; Poussin's first important commission.
1628	The *Martyrdom of St Erasmus* (Vatican), commissioned for St Peter's.
1629–30	Painted the *Madonna appearing to St James the Greater* for Valenciennes, the most overtly baroque of his early pictures.
1630	Married Anne-Marie Dughet, sister of Gaspard Dughet, who under Poussin's influence became a successful landscape painter.

1633	*The Adoration of the Magi* (Dresden), exceptionally signed and dated, and possibly Poussin's reception piece for the Academy of St Luke, of which he became a member in 1631.
1635–6	Two of the Bacchanals for Cardinal Richelieu painted during this period and despatched in May 1636 (see nos. 18–26).
c. 1635	Began series of Seven Sacraments for Cassiano dal Pozzo (see nos. 31–9).
1640	Returned to Paris on the invitation of Louis XIII.
1641	Undertook to decorate the Long Gallery of the Louvre and various other royal commissions, work which was unsuited to Poussin's particular genius. This combined with political intrigue made his period in France an unhappy one.
1642	Despatched from Paris the *Baptism*, no. 37 (from the first set of Sacraments), which Poussin had brought with him unfinished from Italy. Returned to Rome where he remained for the rest of his life.
1644	Began the series of Seven Sacraments for Chantelou (completed 1648) – see nos. 40–55. The death of Pope Urban VIII and the consequent loss of Barberini influence was offset by an increase in the volume of work for French patrons.
1660–4	*The Four Seasons* (The Louvre).
1664	*Apollo and Daphne* (The Louvre), his last work which he gave uncompleted to Cardinal Massimi.
1665	Death of Poussin.

Nicolas Poussin's early years in Rome 1624–c.1633

Nicolas Poussin arrived in Rome, the greatest cosmopolitan metropolis in seventeenth-century Europe, in 1624, just one year after the election of Maffeo Barberini as Pope Urban VIII. He had made the journey from Paris, which at least for an artist was still ranked as a provincial city, at the instigation of his friend Giovanni Battista Marino, the famous Italian poet, who had been living at the court of Marie de' Medici and who had recognized Poussin's artistic talent.

Although many foreign artists, including Elsheimer, Claude, and Rubens, came to Rome in the early years of the century to seek their fortune and to study the remnants of antiquity alongside the great Renaissance masterpieces of Raphael and Michelangelo, they did not find it particularly easy to attract the patronage of the most wealthy and influential collectors. Each successive Pope, and those of his own relations whom he chose to promote to positions of influence and material prosperity, all generally preferred to patronise artists from their native city. It was in this spirit that the Barberini conferred privileges on artists of Tuscan origin, most notably the sculptor Bernini and the painter Pietro da Cortona, both of whom worked in a high baroque style, at the expense of Bolognese artists, including Domenichino and Guercino, whose classical manner had been favoured during the short pontificate of Pope Gregory XV (1621–3). Through his friend Marino, Poussin did secure an introduction to Marcello Sacchetti, a close associate of Pope Urban, who appears to have commissioned the *Battle Scene,* now in the Vatican Gallery (Blunt 1966, no.31). But by 1626 Marcello had already engaged Pietro da Cortona to decorate his villa at Castel Fusano, and therefore failed to provide any major decorative project for the young French artist. It was to the circle of Cassiano dal Pozzo, a learned but far from wealthy lay patron originally from Piedmont, that Poussin quickly gravitated.

Cassiano dal Pozzo (1588–1657) had already been in Rome for 12 years when Pope Urban VIII, following his election, proceeded to offer him a variety of official posts in the Barberini household. But although dal Pozzo accompanied the Pope's nephew, Francesco, on his official missions to Paris in 1625 and to Madrid in 1626, he lacked the necessary political and social

ambition to become a major public figure, preferring to devote his energies to scientific and artistic pursuits. He had a passion above all for science and natural history, was a friend of Galileo, and in 1622 he became a member of Rome's leading scientific society, the Accademia dei Lincei. He was equally absorbed in archaeological research and study of the antique; and employed artists to measure and copy Roman antiquities for his paper museum (Museum Chartaceum) which is still preserved at the Royal Library, Windsor and in the British Museum. Poussin, in need of gainful employment, was almost certainly invited to join the team of artists engaged on this project, although his particular contribution has never been satisfactorily identified. In this way he became absorbed into dal Pozzo's intellectual world, with access to his library and museum which had already attracted international recognition. It may also have been through dal Pozzo that Poussin was introduced to the celebrated Venetian paintings by Bellini and Titian in the Aldobrandini and Ludovisi collections, which were to become one of the major formative influences on his own artistic style during the late 1620s. The seventeenth-century copy of the Bellini/Titian *Feast of the Gods* (no.6) might well have been painted by an artist from within Poussin's circle. During this period Poussin was also exploring the Italian countryside, together with his compatriot Claude. According to Poussin's biographer, Joachim von Sandrart, they even sketched out of doors; and to judge from Poussin's surviving drawings, he was particularly responsive to the visual effects of the strong Italian sunlight, filtered through the hanging branches of the trees which offered shelter in the Roman Campagna.

Poussin's earliest Roman paintings reflect the conjunction of all these influences; the close observation of nature, the art and literature of the antique, and the warm colour and poetic atmospheric effects of Venetian painting, although he never attempted to emulate Titian's sensuous handling of flesh and draperies. The *Venus and Adonis with a view of Grottaferrata* (no.2), which belonged to Cassiano dal Pozzo, evokes nostalgically the spirit of a lost antique world, without any hint of antiquarian pedantry. The figures of Venus and Adonis are absorbed into a landscape which provides the perfect foil to their ephemeral pleasures. Poussin's poetic approach to nature, and in particular the representation of the setting sun against a landscape background to evoke a mood of restlessness and transcience, is used repeatedly in his early mythological works, and nowhere more poignantly than in *The Arcadian Shepherds* (no.5), or more ominously than in the *Acis and Galatea* (no.7) where the dark sombre light reminds us of the tragedy that lies ahead.

Poussin's first real opportunity to break out of the enclosed and protective circle surrounding Cassiano dal Pozzo was offered by Francesco Barberini, who would have known of him both through dal Pozzo and Marcello Sacchetti. Francesco Barberini had returned from Paris in 1625 with a new

enthusiasm for French culture, and this must have prompted his commission for a painting from Poussin of *The Death of Germanicus* (Minneapolis) which was painted in 1627. It is handled in a baroque idiom, with a free painterly style of execution and no clearly defined contours in the modelling of the figures. At the same time its design, clearly influenced by an antique bas-relief, reflects the culture which Poussin had assimilated while working on dal Pozzo's paper museum. Shortly afterwards Poussin was commissioned by the Barberini to paint an altarpiece for St Peter's of *The Martyrdom of St Erasmus,* and this was delivered in 1629. Here too Poussin attempted to emulate the grand manner of established baroque painters such as Pietro da Cortona. The expressive large-scale figures are realistically treated; the handling is broad and painterly; the design is overwhelmingly dramatic. Yet the work was not well received, and the following year Poussin failed to secure a lucrative commission for frescoes in the church of San Luigi dei Francesi. Discouraged both by this setback to his reputation and by the effects of a serious illness, Poussin appears to have lost any ambition to establish himself as a major decorative painter in Rome; instead he turned increasingly to his old mentor, Cassiano dal Pozzo, for help and patronage, on a more modest level.

At this critical turning point in his career Poussin probably painted *The Mystic Marriage of St Catherine* (no.9) which found a place in dal Pozzo's collection, and *The Triumph of David* from the Prado (no.11). Although these works too are essentially baroque, with amply modelled figures, fluid brushwork, and sensuously handled draperies, they lack the emphatic gestures and overpowering naturalistic effects which characterize the altarpiece of *The Martyrdom of St Erasmus.* Their refinement and delicacy has been interpreted as a conscious purification of the high Roman baroque, comparable to the aesthetic of Andrea Sacchi's *Divina Sapienza* fresco in the Palazzo Barberini, which appears to have been designed, although not completed, by 1631 (see D. Mahon in *Gazette des Beaux-Arts,* LX, 1962, pp. 1ff). Certainly this change of emphasis in Poussin's manner cannot be attributed solely to the nature of the subject matter. The theme of *The Triumph of David*, in particular, offered immense scope for exuberant and dramatic effects, which Poussin consciously avoided.

Soon afterwards, between 1631 and 1633, Poussin's attitude to his art underwent a far more radical metamorphosis. Almost overnight he seems to have abandoned his romantic and poetic approach in favour of a rational, highly schematic, classical style. Although shortly after his arrival in Rome Poussin had become a member of Domenichino's drawing academy, it was only at this juncture, in the early 1630s, after Domenichino had moved on to Naples, that Poussin's work began to reflect an awareness of the Bolognese artist's Roman work, and in particular the cool classicism of his narrative fresco cycles. This new influence is first apparent in Poussin's *Triumph of David* (no.13) from the Dulwich Picture Gallery. It offers a

remarkable stylistic contrast to the slightly earlier version of the same subject from the Prado (no.11). The figures are placed like actors on a stage, within a clearly defined three-dimensional space which runs parallel to the picture frame. The overall effect is perhaps somewhat contrived and cerebral. The language of classicism was not yet a natural idiom to Poussin, as it was with the mature Raphael. In this respect Poussin comes closer to the spirit of Domenichino, whose classical style had also been achieved through conscious intent, when he worked as a pupil of Annibale Carracci. Domenichino had in fact begun by purging the late works of his Roman master of their proto-baroque excesses; his *Adoration of the Shepherds* in Edinburgh, which is based on a lost and presumably more atmospheric work by Annibale Carracci, is a supreme example of this critical process (see *Burlington Magazine,* CXV, 1973, pp.525ff).

The attraction to Poussin of his new self-imposed discipline lay in the scope it offered for greater clarity of expression and a more concentrated dramatic focus. He did not aspire to represent the physical splendour of the antique world, in the manner of Michelangelo, or to emulate the idealized human forms conceived by Raphael. He was concerned, above all, with interpreting his subject matter and telling a story with the greatest possible concentration of emotional response. Within the limits of this ambition, Poussin's *Tancred and Erminia* (no.14) which compresses Tasso's elaborate story into a comprehensive image, transcending any single moment in the narrative sequence, while communicating and crystallizing every passion, must be regarded as an early masterpiece, as Jonathan Richardson, one of the first English critics to appreciate Poussin's intellectual and artistic discipline, had already recognized by 1719 (*Essay on the whole art of criticism*; reprinted *The Works of Jonathan Richardson,* 1792 edition, pp.137–8).

(HB)

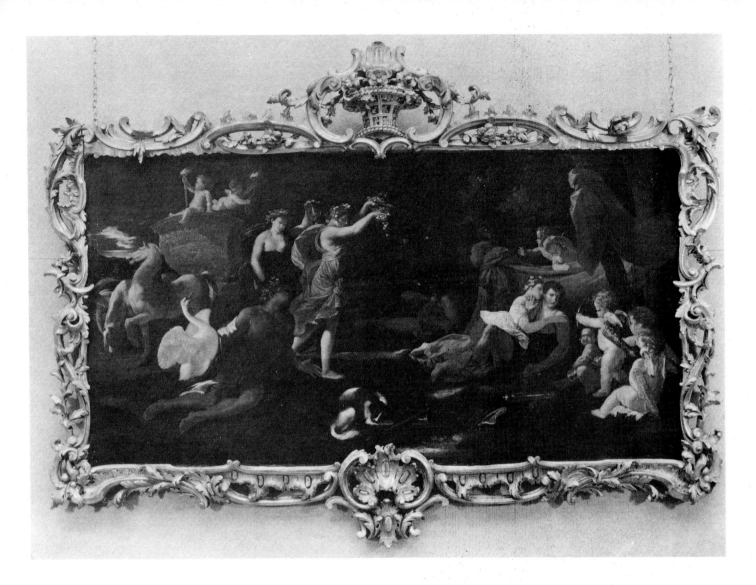

1

Cephalus and Aurora

Oil on canvas; 79×152cm
The canvas was cut down along the top edge to fit its present 18th-century frame (this frame, too fragile to travel, is reproduced here with the picture). The original format of the picture is recorded in a drawing in the British Museum, catalogued as a copy (*CR,* III, no.A56); see fig.1.

The hunter Cephalus, husband of Procris, renounces the advances of Aurora, Goddess of Dawn (Ovid, *Metamorphoses,* VII). Horae come to remind Aurora that the time has arrived for her to depart in her chariot so as not to delay the break of day; one pours dew drops, the other scatters flowers. The winged Zephyrus, with flowers in his head, blows his gentle breath to mark the season of Spring, and embraces the swan which he had caused to sing. An elaborate description of this celebrated picture was published by Bellori (p.460). The fragile elegance of the figures, comparable to those in Poussin's early drawings for Marino, and perhaps

inspired by Poussin's memory of the Fontainebleau school, suggest that this is one of the artist's earliest Italian pictures. Poussin's relative inexperience would also explain awkward passages in the modelling of the figures and of the dog, and the somewhat disordered design and unconvincing perspective. The psychological relationship between the two figures, expressed in Aurora's frustrated embrace and Cephalus's gesture of rejection, offers a remarkable contrast to the unrestrained physical passion expressed in the figures of Venus and Adonis in the picture from Montpellier (no.2). Already

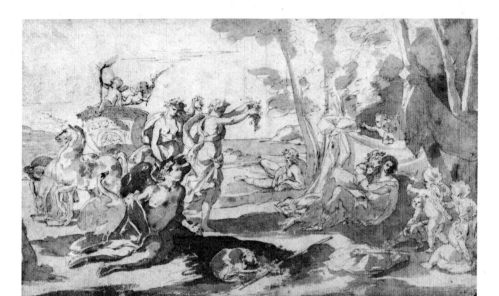

Fig. 1 (not exhibited)
British Museum, London

Fig. 2 Present whereabouts of fragment unknown

Fig. 3 (not exhibited)
Cabinet des Dessins, the Louvre, Paris

here we are aware of the intellectual detachment which characterizes so much of Poussin's art, even in his earliest years.

coll: William Worsley by 1770 (the early provenance is unknown, but it is almost certainly not the *Cephalus and Aurora* recorded in Cassiano dal Pozzo's collection (De Cotte list *c.* 1689 and Gabriele inventory of 1695, no. 114), since the size does not correspond (see A. Brejon, *Revue de l'Art* 19, 1973, pp. 79–96)

ref: Blunt 1966, no. 145

Private collection, Great Britain

18

2
Venus and Adonis with a view of Grottaferrata

Oil on canvas; 75×113cm
Cleaned in 1978, revealing an inscription on the back of the original canvas which reads: AGRI PROPE CRYPTAM FERRATAM PROSPECTUS A NICO...; the remainder of the inscription is cut off from the left-hand edge of the canvas (see C. Whitfield, *Burlington Magazine,* CXXI, 1979, p. 13).

Venus and Adonis embracing. There is an undercurrent of tragedy, of death and resurrection, beneath this overtly sensual theme (Ovid *Metamorphoses,* X). Venus later finds her lover dead, killed by a boar; from his blood springs the scarlet anemone, the flower which immortalizes his memory. The attribution of this picture to Poussin dates from the reliable 1695 inventory of the dal Pozzo collection, where it is described as a view of Grottaferrata measuring 9×3 *palmi.* This corresponds with the size of the Montpellier picture as we see it now, plus a fragment cut from the left-hand side which was recently

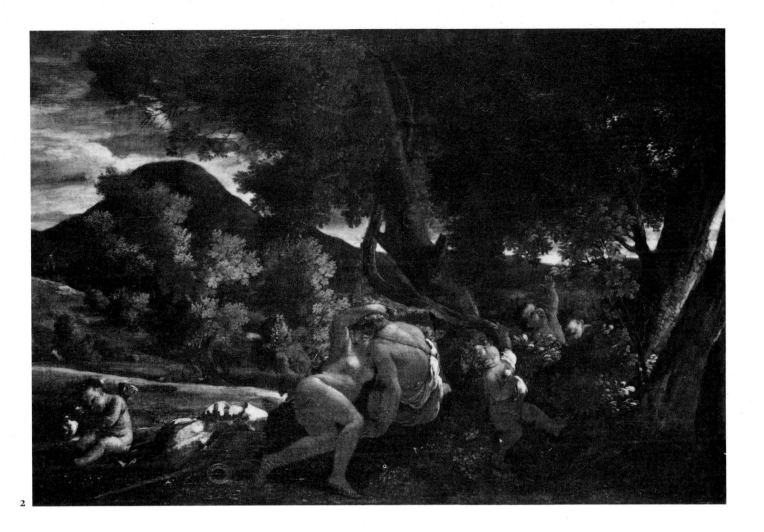

2

recognized by Whitfield from an old
photograph (*Burlington Magazine,* CXXII,
1980, p.838, fig.25); see fig.2.
Notwithstanding the old attribution of the
Montpellier picture to Poussin, reiterated in
a 1715 inventory where it is described as a
sopraporta (i.e. a decorative painting hung
over a door) it was only in 1977 that Pierre
Rosenberg (Rome exhibition catalogue)
convincingly propounded the view that the
picture might be one of Poussin's earliest
Roman works. The picture is remarkable
above all for its romantic and nostalgic
atmosphere, anticipating the mood of the
Dublin *Acis and Galatea* (no.7); for the

relationship between the form of the trees
in the landscape and the posture of the
intertwined human figures below; and
above all for the poetic observation of
natural phenomena, such as the pink light
from the sunset filtered through the foliage
of the trees onto the figures below. This
sensitivity to nature is matched in a series of
18 drawings (including *A Path through a
Wood,* Louvre inv.32464; see fig.3), possibly
from a single sketchbook, all traditionally
attributed to Nicolas Poussin (see M.
Chiarini, *Paragone,* 187, 1965, pp.63f; but
cf. J. Shearman in *CR,* IV, nos.G1–18 for an
alternative attribution to Gaspard Dughet).

coll: Cassiano dal Pozzo (inventory of
Gabriele dal Pozzo, 1695 (113)) and later
lists: see A. Brejon, *Revue de l'Art* 19, 1973,
pp.79–96; and C. Whitfield, *Burlington
Magazine,* CXXII, 1980, p.838; Boccapaduli,
Rome; François-Xavier Fabre who gave it
to the Montpellier Museum in 1825

exh: Rouen 1961, no.106; Rome 1977, no.2

ref: Blunt 1966, no.R105; and further in
Burlington Magazine, CXV, 1978, p.422 and
CXXII, 1980, pp.577ff

Musée Fabre, Montpellier

3

Two heads from an Adoration of the Golden Calf

Oil on canvas; 32·5×45·5cm

A fragment from an *Adoration of the Golden Calf,* painted for a Neapolitan patron, which was subsequently damaged in the Masaniello revolt of 1647 (see Félibien IV, p.24). The picture was painted over another composition, its axis at right angles to the present picture. It included a view of the Colosseum with ruins; this is clearly visible in X-ray photographs (p.113). It is obviously an early work. The heads are similar in type to those in the *Mystic Marriage of St Catherine* (no.9), but the handling is less delicate, with much less impasto, and the modelling is less refined. It is probably datable *c.* 1627–9.

coll: Earls of Carlisle; by inheritance to George Howard who sold it in 1944; Cecil Liddell; Mrs John Booth

exh: Paris 1960, no.13

ref: Blunt 1966, no.27

Private collection, Great Britain

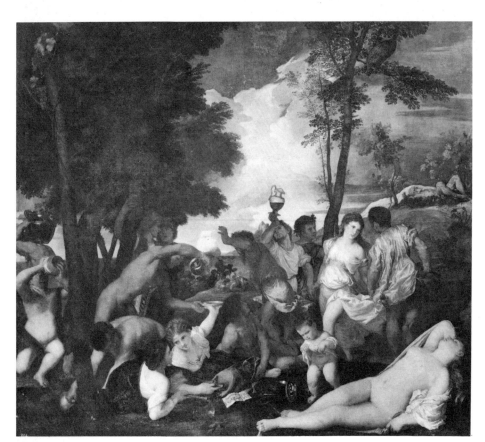

Fig.4 The Prado, Madrid

4

The Andrians
(Bacchanal with lute-player)

Oil on canvas; 121×175cm

The scene is based on Philostratus' description in *Imagines* I, section 25. The island of Andros flows with wine, due to the intervention of Bacchus. Poussin was obviously inspired by Titian's celebrated picture on the same theme, now in the Prado, Madrid (fig.4), but accessible to him in the Ludovisi collection in Rome. The figure of the river god on the left, reclining on a couch of grapes, is taken directly from Bellini's *Feast of the Gods* (it was completed by Titian), from the Aldobrandini collection, and now in the National Gallery of Art, Washington (see also no.6, for a Roman copy). Poussin's design is much more static than the Titian prototype; and his robust rather wooden figures are assembled in the foreground against a dark and warmly coloured romantic landscape which itself lacks structure or convincing three-dimensional depth. There is no attempt to imitate Titian's subtle handling of flesh tones and richly sensuous treatment of draperies. The simplicity of Poussin's

4

manner might suggest that he was ultimately more sympathetic to the spirit of Bellini's *Feast of the Gods* with its well-drawn classical design, inanimate but highly suggestive figures, and its frieze-like background of trees silhouetted against the warmly coloured sky at sunset. *The Andrians* is similar in style, above all in the warmth of its colour, to the *Death of Germanicus* (Minneapolis) of 1627 and might well date from *c.* 1627–8, as previously suggested by Thuillier (1974, no.47) and Rosenberg (Rome exhibition catalogue, 1977).

coll: Duc de Richelieu, possibly acquired by inheritance from his great-uncle, Cardinal Richelieu; acquired by Louis XIV in 1665

exh: Paris 1960, no.30; Rome 1977, no.15

ref: Blunt 1966, no.139

Musée du Louvre, Paris

5

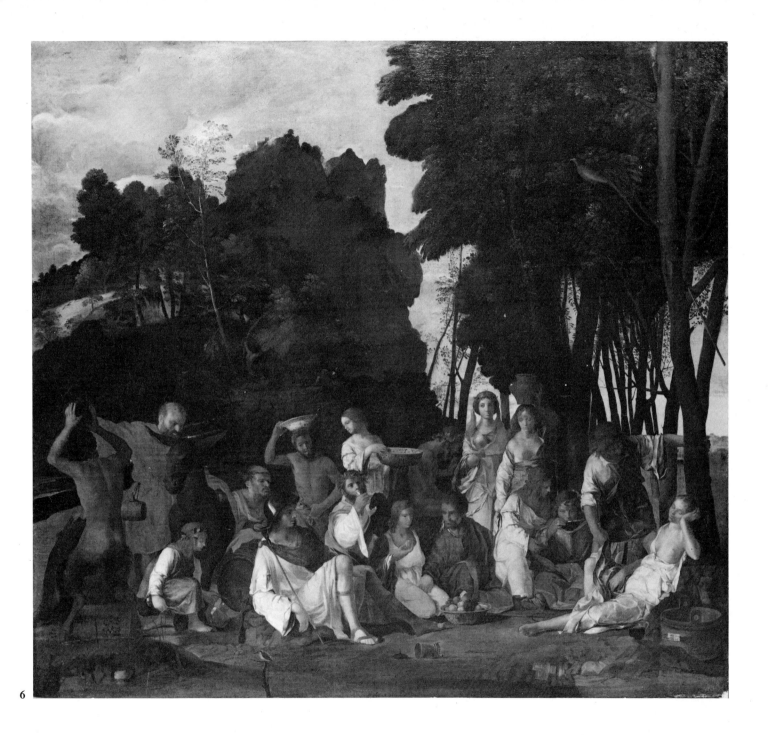

6

5

The Arcadian Shepherds

Oil on canvas; 101 × 82cm
There is an addition of c. 8cm on the left

The concept of a tomb in Arcadia can be traced to Virgil. But the phrase on the tomb *Et In Arcadia Ego* was not coined until the 17th century, and there is no agreement as to its precise meaning. Nevertheless the underlying concept of a *memento mori,* of the inevitability of death even for those who inhabit an arcadian world, is clear. By 1677 the picture was paired in the Massimi collection, Rome, with a picture of *Midas washing at the source of the River Pactolus* (Metropolitan Museum, New York); but the two pictures were not necessarily painted at exactly the same time. The *Midas* is more broadly handled, especially in the modelling of the figures and its dark-toned landscape suggests it may date not too far from *The Andrians* (no.4). *The Arcadian Shepherds* has a lighter-toned background, with delicate silvery foliage in the trees, which prompts comparison with *The Triumph of Flora* in the Louvre. These stylistic comparisons might suggest a date of around 1627–8 both for *The Arcadian Shepherds* and the *Midas.*

coll: Cardinal Camillo Massimi; on his death in 1677 bequeathed to his brother Fabio Camillo Massimi; first recorded in England in the possession of the Duke of Devonshire in 1761; by descent through the Dukes of Devonshire

exh: Paris 1960, no.19

ref: Blunt 1966, no.119

Trustees of the Chatsworth Settlement

After Giovanni Bellini

6

The Feast of the Gods

Oil on canvas; 174 × 192·4cm

A full-size replica of the picture painted by Bellini in 1514 for Alfonso Ferrara, and later completed by Titian, which is now in the National Gallery of Art, Washington. It was in the hands of the Aldobrandini family from 1598 and remained in Rome until the 19th century. The picture is generally agreed to be a copy of exceptionally high quality, dating from the 17th century. Apart from the colours, which have altered since it was painted, it reproduces faithfully everything that is visible in the original painting, including even the exact form of its signature. It has been associated with Poussin since at least 1849; but there is no documentary evidence that he ever painted such a picture, and most modern critics have cast doubt on the attribution. The influence of Bellini's picture is readily apparent in early works by Poussin such as *The Andrians* (no.4), as well as in the landscape background of *The Triumph of Pan* from the Richelieu Bacchanals (no.18). On the other hand there was no need for Poussin to make a literal copy simply to absorb the spirit of Bellini's painting (cf. Félibien IV, p.13).
A copy of this kind must have been commissioned by a collector; yet one cannot exclude the possibility that Poussin might have accepted such employment during his early years in Rome, when he lacked sufficient work.

coll: W. Coningham sale 1849, as by Poussin; Sir Charles Eastlake who gave it to the National Gallery of Scotland in 1862–3

exh: Paris 1960, no.28

ref: Blunt 1966, no.201; also in *Burlington Magazine,* CXVI, 1974, p.762

National Gallery of Scotland

7

Acis and Galatea

Oil on canvas; 97 × 135cm

The picture follows Ovid's account of the story of Acis, son of the god Faunus, and the sea nymph Galatea in *Metamorphoses* XIII. The two passionate lovers are shown in the foreground surrounded by the river gods. The Cyclops Polyphemus pipes in the background. There is an undercurrent of tragedy beneath this idyllic scene. For Polyphemus too became infatuated by Galatea, and in a fit of jealousy threw a huge rock at Acis, crushing him to death. The picture's dark tone and warm colouring prompt stylistic comparison with the documented *Death of Germanicus* of 1627 (Minneapolis) and *The Andrians* (no.4). However, the romantic and nostalgic evocation of the spirit of a lost antique world, and the brittle, almost mannered elegance of the figures might suggest that this picture could be slightly later in date (cf. Pierre Rosenberg in the Rome exhibition catalogue 1977). It is particularly close in mood to the pictures and etchings, often on themes of unrequited love, which the Lucchese artist, Pietro Testa, produced from c. 1632 onwards when he too became closely associated with the circle of Cassiano dal Pozzo (cf. his *Venus and Adonis* fig.5).

coll: The early provenance is not known; Earl Spencer by 1831; Sir John Leslie, 1856; Sir Hugh Lane who bequeathed it to the National Gallery of Ireland in 1916

exh: Rome 1977, no.19

ref: Blunt 1966, no.128

National Gallery of Ireland, Dublin

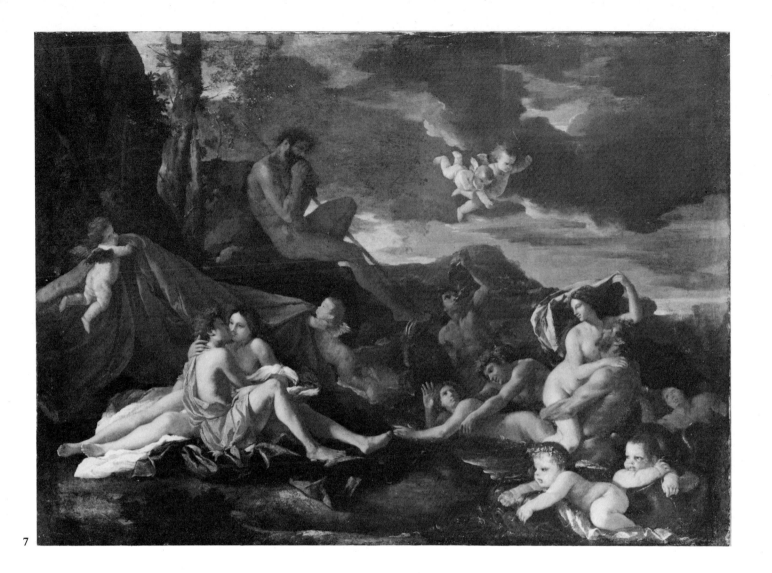

7

Fig. 5 Pietro Testa

25

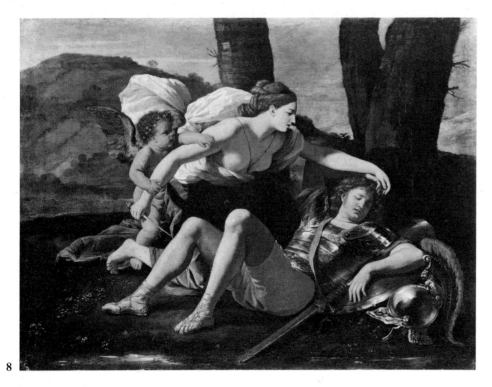

The Mystic Marriage of St Catherine

Oil on wood; 126×168cm
Painted on five oak planks lying
horizontally (considerable paint losses
along the joins of the planks, especially the
topmost join). The whole panel appears to
have been sawn through 42cm from the
right-hand edge, and joined together again.

St Catherine of Alexandria had failed to
find a worthy suitor. She dreams that the
Virgin brings her to the Infant Christ as His
Bride, but she is rejected. A hermit baptizes
her. The Infant Christ then accepts her as
His bride. She later became a Christian
martyr, being executed for refusing to
worship pagan idols. X-rays (see p.114)
reveal either extensive changes to the
central area of the design, or else a different
composition altogether. It is possible to
discern a hooded female figure, seen in
profile, in the centre of the picture, and the
heads of two boys or angels behind,
towards the left. A variant of the
composition, with the martyrdom of St
Catherine in the right background, is
recorded in a drawing at Cleveland (see
no.10, below). Although the drawing is not
by Poussin it may represent an earlier stage
in the design and execution of our picture;
the outstretched hand of the male figure
standing behind St Catherine in the
drawing may be detected beneath the paint
surface of our picture. The large oak panel,
not used elsewhere in Poussin's work, and
certain weaknesses and uncharacteristic
passages in the painting have led to doubts
about Poussin's authorship, and an
unconvincing proposal to attribute this and
other pictures to Charles Mellin (see D.
Wild, *Gazette des Beaux-Arts*, LXVIII, 1966,
pp.204f). The old attribution to Poussin in
the dal Pozzo collection is important, and
the picture's style relates it particularly to
The Martyrdom of St Erasmus (Vatican) of
1628–9 and *The Virgin appearing to St James*
(Louvre), commissioned in 1629, where
one finds the same amply modelled figures
and painterly handling. It also seems
particularly close in style to *Rinaldo and
Armida* at Dulwich (no.8) and *The Triumph
of David* in the Prado (no.11). Of these the
Rinaldo and Armida is the most powerfully
modelled, and the colouring of the
draperies is particularly intense. *The
Triumph of David* is more delicate and
refined, both in structure and tone. *The
Marriage of St Catherine* which may date
from around 1629 stands midway between
them.

8

Rinaldo and Armida

Oil on canvas; 80×107cm

The subject is from Torquato Tasso's
heroic poem *Gerusalemme Liberata,* XIV,
published 1581. It tells of the liberation of
Jerusalem during the first Crusade.
Rinaldo, the Christian hero, has been
enchanted by Armida, the Saracen. She is
about to kill him but is overcome by love.
X-rays show signs of another painting
beneath the paint surface, its axis at right
angles to the present picture, but the design
is not clear and the subject remains
unidentified. The firm sculptural forms of
the amply modelled figures prompt
comparison with the *Mystic Marriage of St
Catherine* (no.9). The broadly painted
draperies, reminiscent of Venetian painting
in the intensity of their colour, are also close
to those in the *Mystic Marriage*. It seems
very likely that both pictures were painted
around 1629, soon after Poussin's
large-scale baroque altarpiece of the
Martyrdom of St Erasmus (Vatican), 1628–9.

coll: Noël Desenfans by 1804; Sir Francis
Bourgeois who bequeathed it to Dulwich
College in 1811

exh: Paris 1960, no.14

ref: Blunt 1966, no.202

Dulwich Picture Gallery, London

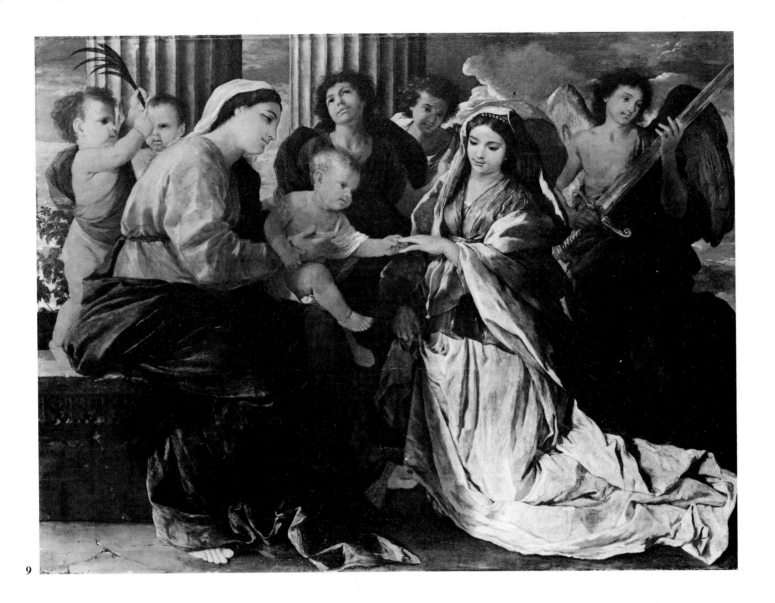

9

coll: Cassiano dal Pozzo (inventory of Carlo Antonio dal Pozzo, 1689, and later lists: see F. Haskell and S. Rinehart, *Burlington Magazine,* CII, 1960, pp.318–26; and A. Brejon, *Revue de l'Art,* 19, 1973, pp.79–96; Humphrey Morice, Chiswick, in 1781; Lord Ashburnham 1786; Ashburnham sale 1850; Samuel Woodburn; T. Kibble sale 1886; Sir Herbert Cook; by descent to Sir Francis Cook; Thos Agnew's 1946; Sir John Heathcoat Amory who bequeathed it to the National Gallery of Scotland (received 1973)

ref: Blunt 1966, no.95; and in *Burlington Magazine,* CXVI, 1974, p.762

National Gallery of Scotland

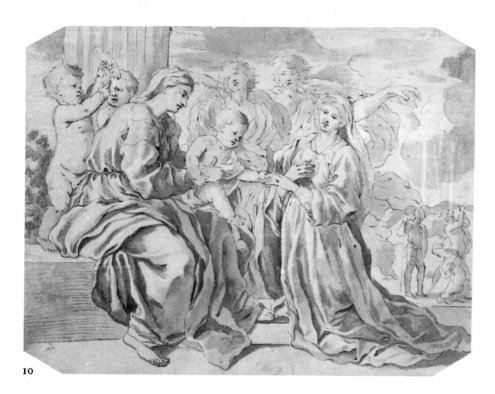

10

After Nicolas Poussin

10

The Mystic Marriage of St Catherine

Pen and brown ink with brown and grey washes; 288×389mm

By an anonymous draughtsman of the later 17th century and most probably a record of a lost compositional study by Poussin.

Cleveland Museum of Art (The Norweb Collection (54.686))

11

The Triumph of David

Oil on canvas; 100×130cm

David with the head of Goliath, crowned by a winged figure of Victory. Traces of an architectural setting, with a regular series of arches, is discernible beneath the paint surface. The picture has not been X-rayed, so it is not clear whether it was painted over an earlier one, or whether the alterations refer to an earlier stage of the present design. In style, the picture represents a development from the *Mystic Marriage of St Catherine* (no.9) and the Dulwich *Rinaldo and Armida* (no.8), with more refined brushwork, more delicate and less sculptural modelling, and a subtler use of light. It might date from around *c.*1630–1, anticipating the exceptional refinement of the Dresden *Kingdom of Flora* which was delivered in the spring of 1631, and the *Echo and Narcissus* in the Louvre, Paris. In any case it must certainly precede the Dulwich version of the same subject (no.13), which reinterprets the scene as a dramatic narrative, and marks the early stage in a stylistic development which led to the first series of Sacraments. The picture was singled out for particular praise by Bellori (p.468).

coll: Mentioned by Bellori as belonging to Monsignor Girolamo Casanate; acquired by the painter Carlo Maratta (died 1713) and bought from his heirs by Philip V of Spain; recorded in Philip's collection at La Granja in 1746

exh: Rouen 1961, no.74

ref: Blunt 1966, no.34

The Prado, Madrid

28

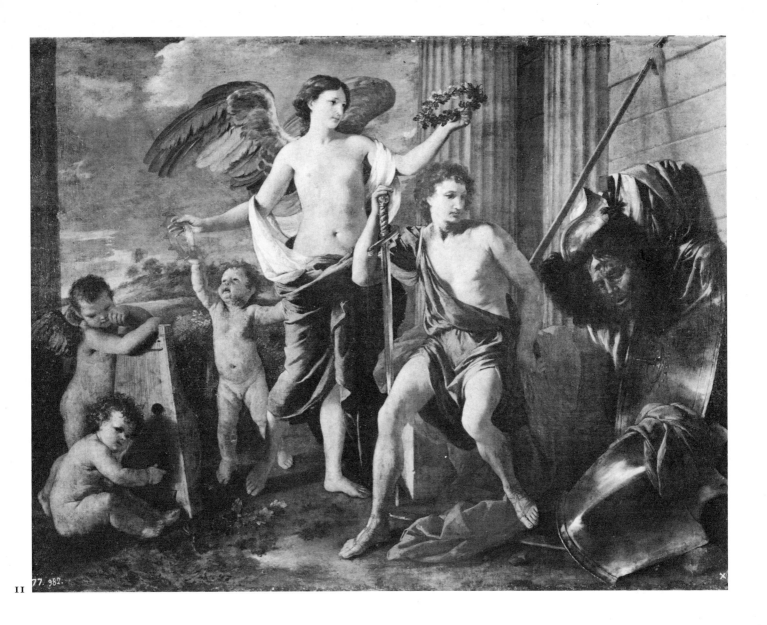

29

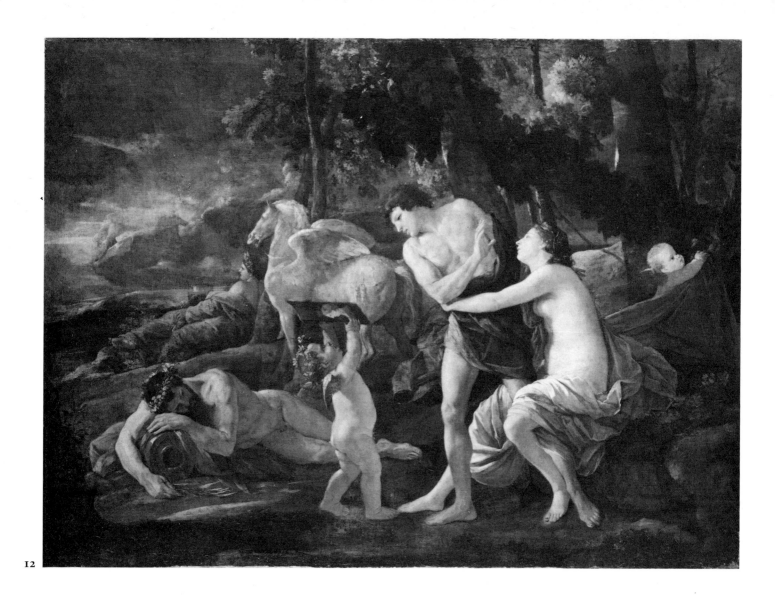

12

In the 'Cephalus and Aurora', of Nicolo Poussin in our National Gallery, the substitution of Apollo for the rising sun, as he has managed it, is in the highest degree poetic. But the thought alone is a mere imitation of the poets, which might have occurred to the most prosaic mind. It is entirely, therefore to the technical treatment – to the colour, and to the manner in which the forms of the chariot and horses of the god melt into the shapes of clouds, in fact, to the chiaroscuro, that the incident, as connected with the picture, owes its poetry . . .

(C. R. LESLIE, *A Handbook for Young Painters*, 1855, p.24)

12

Cephalus and Aurora

Oil on canvas; 96·5 × 130·5cm

Aurora, Goddess of the Dawn, attempts to seduce Cephalus, who is married to Procris (Ovid, *Metamorphoses,* VII). A putto holds up a portrait of Procris, which strengthens Cephalus's resolve to disengage himself from the clutches of the goddess. Apollo, the sun god, looks into the landscape awaiting the dawn, which is already breaking, notwithstanding the absence of Aurora. Pegasus, the winged horse, stands by. A river god, probably Oceanus, reclines in the foreground. There are numerous *pentimenti* in the paint surface, and X-rays (p.113) reveal a two-wheeled chariot, presumably Aurora's, which was subsequently painted out; it occupied the space now taken by Pegasus and Apollo. The figure of Cephalus, seen in profile, is taken from Titian's *Bacchus and Ariadne,* now in the National Gallery, London, available to Poussin in the Aldobrandini collection in Rome. The softness of the forms in Poussin's painting, the delicate painterly handling, and the relatively light tone, together suggest a date around 1630, more or less contemporary with the Prado *Triumph of David* (no.11).

coll: Mme d'Hariague sale, Paris 1750; John Knight, London by 1816; bequeathed to the National Gallery, London by G. J. Cholmondely 1831

ref: Blunt 1966, no.144

The Trustees of the National Gallery, London

13

The Triumph of David

Oil on canvas; 117 × 146cm

David takes the head of Goliath to Jerusalem (I Samuel, xvii). X-rays (p.112) reveal numerous major changes in the design (see S. Rees Jones, *Burlington Magazine,* CII, 1960, p.308, figs.14, 15 and 18). (1) The architectural background has been changed. Originally it was a portico with a flat entablature, supported on columns at the left and pilasters at the right. (2) The original form of the temple itself is not clear in the X-ray, perhaps because Poussin scraped off some of the original paint. The present double row of fluted columns has replaced an arcade. (3) There are numerous changes among the figures emerging from the temple. (4) The group of three women on the extreme left of the picture in the foreground were originally painted much further to the right. They were moved to open up a space in front of the trumpeter. The transfer of these figures was apparently effected by means of a pricked cartoon, now in the collection at Chantilly. The final design of the picture was clearly influenced by Domenichino's fresco of *The Flagellation of St Andrew* in the Oratory of St Andrew in the church of San Gregorio in Celio in Rome (fig.6).

The stage-like setting, the placing of the architectural background exactly parallel to the picture plane, the diminishing scale of the figures, also arranged in parallel planes, and the carefully calculated intervals of space which isolate and define the individual figures' forms, are all concepts derived from Domenichino. The logical structure of the picture's design in no way diminishes the atmosphere of vitality and spontaneous exuberance. This picture marks a major development in Poussin's style and must be close in date to *The Adoration of the Magi* in Dresden, which was delivered in 1633. A date of around 1631–3 seems most likely.

coll: Pierre Lebrun, Paris, sold to B. Vandergucht, London, before 1771; second Lord Carysfort by 1776; C. A. de Calonne, *c.*1787; bought Noël Desenfans 1795; Sir Francis Bourgeois who bequeathed it to Dulwich College in 1811

exh: Paris 1960, no.9

ref: Blunt 1966, no.33

Dulwich Picture Gallery, London

'. . . a mind thrown back two thousand years, and as it were naturalized in antiquity . . .'

(REYNOLDS, *Discourses,* 1788)

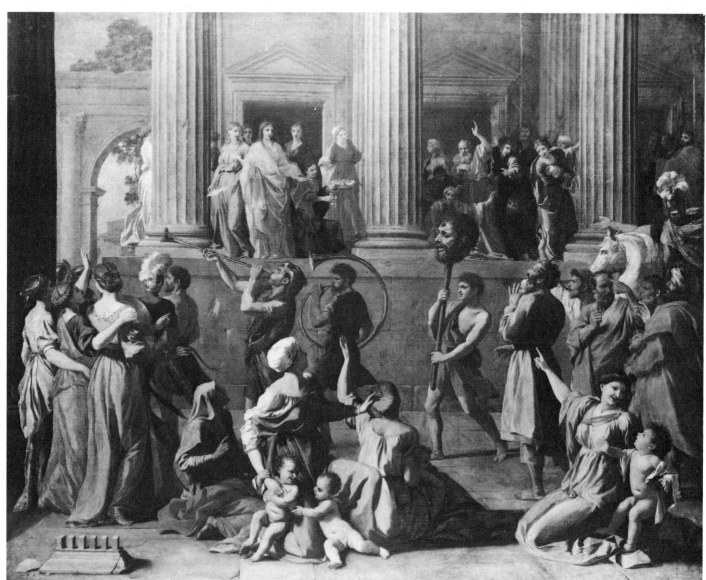

13

32

Tancred and Erminia

Oil on canvas; 55×100cm

The subject is from Torquato Tasso's heroic poem *Gerusalemme Liberata,* XIX, published in 1581. Tasso tells the story of how Tancred, the Christian hero, killed the pagan giant, Argante, in self-defence; and how Erminia, who was in love with Tancred, bound his wounds with her own hair, in the presence of his squire Vafrino. An earlier version of the same subject by Poussin, painted in his warm-toned romantic style of the 1620s, is in the Hermitage Museum, Leningrad. Here, in marked contrast, the tonality is bright, and the figures are firmly modelled, with meticulously handled draperies, apart from one pentiment affecting the arrangment of the robe across Tancred's body. This clarity of execution, compromized only by the uncertain perspective; the artist's masterly compression of the narrative; the lively gestures and facial expressions of the figures; together might suggest that the picture dates from the early or mid 1630s when Poussin first began to concentrate on dramatic narrative and formal classical design. It would certainly appear to be more advanced than *Rinaldo and Armida* (no.8) where the story is conveyed in a much less forceful manner, with broader handling and a more suggestive sensual atmosphere.

coll: Bought by Sir James Thornhill in Paris in 1717; his sale London 1734 bought W. Lock; Earl Poullett, from whose descendant it was bought by the Barber Institute of Fine Arts, Birmingham 1938

exh: Paris 1960, no.53

ref: Blunt 1966, no.207

The Barber Institute of Fine Arts, Birmingham

14

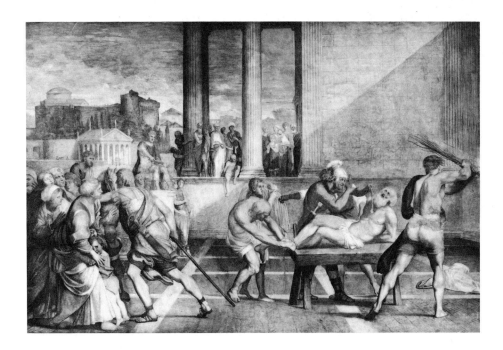

Fig.6
Oratory of St Andrew, San Gregorio in Celio, Rome

Sacraments and Bacchanals:
variations on a classical style 1633–48

Poussin's principal concern for the remainder of the 1630s, prior to his departure to Paris in 1640, was to explore the variety of stylistic approaches that could be contained within the limits of a classical aesthetic. His extraordinarily inventive work during this period offers a remarkable demonstration of just how unrestrictive a classical style could be. Paradoxically he achieved this important stylistic breakthrough at precisely the moment when his earlier romantic manner was attracting followers among the rising generation of Italian artists who came to Rome in the early 1630s.

Pietro Testa, an artist from Lucca, had taken refuge in Cassiano dal Pozzo's circle, following the failure of a decorative project in his native town in 1632, and then proceeded to produce a magnificent sequence of intimate prints and drawings, showing landscapes and mythological subjects, strongly coloured by Poussin's Venetian manner (the Gallery has a complete set of his prints and a wide selection of his drawings). The Genoese artist, Giovanni Benedetto Castiglione, who visited Rome *c.*1632 and who by 1634 was a member of the Accademia di San Luca, to which Poussin also belonged, now fell, temporarily at least, under the spell of what his biographer, Sandrart, described as the *Antiche Manier* and in 1633 painted a *Pastoral Journey* (private collection, New York) in which both figures and landscape are derived from Poussin's early style (see *Burlington Magazine,* CXXII, 1980, pp.293ff, fig.1). Even in the middle years of the fourth decade, when Poussin had decisively moved towards a classical style, yet another follower, known as the Silver Birch Master, and sometimes identified as Poussin's brother-in-law, Gaspard Dughet, (but cf. C. Whitfield, *Burlington Magazine,* CXXI, 1979, pp.13ff for a controversial suggestion that he might be Poussin himself), was almost obsessively imitating the least classical element of Poussin's new manner, the unidealized closely observed landscape backgrounds that provide a decorative screen to pictures such as *The Triumph of Pan* (no.18), *St John baptizing the people* (no.30), and *Ordination* (no.31). (Two of the finest decorative works by this hand *Landscape with a nymph riding a goat* and *Landscape with a faun and reclining nymph* from a private collection will be exhibited in the Gallery during the exhibition.)

Poussin's stylistic development during the 1630s was essentially a solitary achievement. It was a path which even the other artists in his own circle simply failed to follow. In making so decisive a break with his earlier romantic style, Poussin was assisted by further generous support from his mentor, Cassiano dal Pozzo, who ordered a series of paintings which were to represent each of the seven Holy Sacraments, as a narrative in a strictly historical context, showing their origin in the early years of the Christian Church in Rome. We do not know if it was the patron or the artist himself who first conceived this project. In any case it offered Poussin the challenge of a fresh approach to antiquity, and ample scope to develop his new interest in dramatic story-telling and psychological expression, on a suitably intimate scale.

In the series of Holy Sacraments for dal Pozzo, Poussin, far more than any classical artist before him, was concerned above all else with capturing the precise emotional response of each individual figure to a human situation. Raphael, in his celebrated tapestry cartoons showing narrative scenes from the Acts of the Apostles (Victoria and Albert Museum, London), which provide a fair basis of comparison with Poussin's narrative style of more than a century later, was far more preoccupied with the geometric clarity of his design and the ordering of his figures into expressive groups than with the subtle communication of individual emotional states; his figures have a massive sculptural quality and an insistent physical presence. Only Annibale Carracci, in certain small-scale relatively late works, such as *Christ appearing to St Peter* of *c.* 1602 (fig.20) from the Aldobrandini collection in Rome (now National Gallery, London) and the *Martyrdom of St Stephen* (Musée du Louvre, Paris) of *c.* 1603–4 had already approached the intimate and concentrated theatrical language of expression which Poussin developed in the series of Sacraments for dal Pozzo (see further D. Posner, *Annibale Carracci. A Study in the Reform of Italian Painting around 1590*, 1971, I, pp.130ff). On a more theoretical level the French artist would also have found encouragement in Leonardo da Vinci's naturalistic observation that inward emotional states could be conveyed, with some precision, through appropriate physical actions and the attitudes and movements of the limbs. Poussin had been obliged to study Leonardo's *Treatise* (the manuscript was in the Barberini Library), following a commission from Cassiano dal Pozzo to design illustrations for a published edition which eventually appeared in 1651.

By throwing the principal emphasis onto the individual response of each figure within a painting, Poussin was at once in danger of disrupting the overall unity of his design. The problem was particularly acute where the subject lacked strong dramatic impact to provide a focal point, as in *Ordination* (no.31); but it also affects more animated and crowded scenes such as *Moses striking the rock* (no.28) which dates from about the same period as the first series of Sacraments. In *Ordination* the Apostles are

casually arranged as an essentially passive group against the shallow landscape which, while providing a decorative backdrop, notable for its obsessive attention to details of foliage and the surface of tree trunks, has no structural framework to give coherence and stability to the design. The correction of this weakness in *Extreme Unction* (no.33), which may come slightly later in the sequence of Sacraments, and where the figures are grouped with impressive lucidity in a clearly defined architectural environment, involved some loss of dramatic clarity, and the relationship of each individual to the dying man is not always adequately particularized; yet the expression of the mourners' grief is masterly, with none of the over-emphasis that characterizes the baroque style of Poussin's contemporaries. In *Confirmation* (no.35) Poussin's potential skill as a story-teller is at last fully realized; but here, as in *Extreme Unction,* the individual figures are never allowed to impair the visual coherence of the overall composition. This picture, above all, provides a fascinating insight into Poussin's growing capacity to evoke a mood of contemplation, through the beauty and precision of abstract forms, without in any way undermining the dramatic vitality of the story. This tendency to abstraction is further developed in *Baptism* (no.37), documented as the last picture in the dal Pozzo series of Sacraments. Both the figures, which are now much larger, and the landscape, assume a new monumentality; and this formal concern takes precedence over the simple design to tell a human story, or to observe the unidealized forms of the natural world.

Abstract form and closely integrated surface design are even more self-consciously developed in the two Bacchanals of *The Triumph of Pan* (no.18) and *The Triumph of Bacchus* (no.24) which Poussin, in 1635, was invited to paint for Cardinal Richelieu, the French Prime Minister and also the country's leading collector. In works of this kind the nature of the subject matter rules out any concern with emotional expression or complex psychological relationships. Instead this commission provided Poussin with an irresistible challenge to emulate the physical exuberance which gives such vitality to the art of the antique and also of the Italian High Renaissance. Yet it was Annibale Carracci's celebrated *Triumph of Bacchus* ceiling decoration in the Palazzo Farnese, dating from *c.* 1597–1600, which offered Poussin the most obvious and accessible prototype. Some of the panache of Annibale's invention, which had successfully fused Roman design with Venetian colour, is indeed assumed by Poussin in an early preparatory drawing for his own *Triumph of Bacchus* (fig.15). However the baroque sense of diagonal movement that characterizes the drawing is abandoned in the final picture, which has the tight integrated form of an antique bas-relief. Its pendant, *The Triumph of Pan,* although executed with more vigour and delicacy, is equally two-dimensional in design; yet within these formal limits the untroubled pagan figures are allowed to move with the effortless physical ease of ballet dancers. The tonality of both pictures, which is unusually bright and clear, with strong intense local colours for

the draperies, conveys a mood of nervous sexual energy and erotic frenzy, which gives a sense of immediacy to the archaeological reconstruction of these pagan celebrations. This is in marked contrast to the romantic, brooding sensuality of Poussin's earlier Bacchanals dating from the 1620s, such as *The Andrians* (no.4), where the artist's approach to antiquity was still coloured by the poetic atmosphere of Titian's *poesie* in the Aldobrandini and Ludovisi collections.

Richelieu also commissioned a *Triumph of Neptune* (no.27) which was probably painted at the same time as *The Triumph of Pan* and *The Triumph of Bacchus,* although it did not form part of the same series. Here, in a composition which is much more open and three dimensional, and where the concentration on sea and air gives the artist unlimited scope for ravishing painterly effects, Poussin comes closer than ever before to the heroic manner of the Roman High Renaissance, confidently evoking the physical splendour of the classical world, while breathing fresh life into its imagery. It is a *tour de force,* brilliantly handled with the most delicate light brushwork which consciously evokes an impression of antique wall painting.

Poussin's impressive work for Cardinal Richelieu was enough to earn him a prestigious invitation to return to his home country, and work for King Louis XIII. The official invitation came from Richelieu and his artistic adviser, François Sublet des Noyers, in January 1639, but it was not until December 1640 that Poussin finally made his departure from Rome, accompanied by Sublet des Noyers' cousin, Paul Fréart de Chantelou, who had been sent to fetch him. Chantelou, for whom Poussin had already painted an impressive picture of the *Israelites gathering the manna* (Musée du Louvre), would soon become the French artist's most important patron. Poussin's short stay in Paris was not a happy one. He was required to prepare designs for large-scale decorative projects, including a scheme for the Long Gallery of the Louvre, which were ill-suited to the intimate and meticulous style he had developed in Rome; and finally in the winter of 1642 he decided to return to Italy, where he remained until his death in 1665. From this moment onwards, however, many of his principal commissions would come from French bourgeois collectors, such as Chantelou, with whom he had established contact in Paris.

Even while Poussin was still in France, Chantelou was already making efforts to persuade the artist to provide copies of the seven Holy Sacraments, of which the last in the series, *Baptism,* had still to be completed. Poussin was reluctant to do such routine work himself; he was equally unwilling to entrust the task to others. Eventually, in January 1644, he offered to design an entirely new set of pictures on the same theme. 'I assure you, Sir', he wrote to Chantelou from Rome on 12 January, 'that they would be worth more than copies, cost hardly more and take no longer to do.'

On reflection, Poussin probably welcomed this opportunity to revise the dal Pozzo series of pictures. It seems very likely, if only from stylistic evidence which is discussed more fully in the catalogue entries, that the execution of these Sacraments was spread over an extended period. They might well have been started before Poussin became involved with the important Richelieu commission during 1635–6; and although six of the pictures had been delivered by 1640, the completion of the set was then interrupted by Poussin's invitation to Paris.

The first set of Holy Sacraments lacks homogeneity, not only because of the variety of approaches the artist has brought to the composition of each successive picture, as he explored the full potential of his classical style, but because of marked differences in handling and tonality. *Confirmation* (no.35) and *Eucharist* (no.34) stand apart from *Ordination* (no.31), *Marriage* (no.32), and *Extreme Unction* (no.33) by virtue of their dark ground and the dramatic lighting effects. *Baptism* (no.37), with its larger figures and firm structured landscape, is readily distinguishable from all the earlier pictures in the set and in particular from *Ordination* which has a quite different type of landscape background. Shown together, in a single room, with no pictures by other artists (cf. Inventory of Gabriele dal Pozzo 1695; information from A. Brejon), this series of Sacraments must have been remarkably difficult to display effectively.

After Poussin's return to Rome, in 1642, his style assumed a new level of gravity, formal coherence, and above all consistency. As Friedlaender has observed: 'All the elements that had been previously individualized and juxtaposed were now subordinated to a greater, more unified conception' (p.61). Nowhere do we see this more effectively than in the second series of Holy Sacraments. All the nicely observed details in the treatment of figures, and in the landscape and architectural backgrounds, that together add gaiety, vivacity, and variety to the first series of Sacraments, but which nevertheless distract attention away from the central historical and religious theme, are deliberately excluded from the more austere Chantelou pictures. In consequence the second set of Sacraments exhibits a degree of rational control and dramatic intensity that is absent from the earlier and more spontaneous dal Pozzo pictures. The figures, although still arranged in a stage-like setting, are proportionally much larger in relation to their environment, and now assume a monumental quality. They participate in a solemn ritual, remote both in time and place from the spectator's world, while still remaining intensely human in their emotional language. Their passions are more concentrated and idealized; and they are expressed less rhetorically, with a subtler and more comprehensive range of facial expressions and physical gestures. Superb passages of abstract design, such as the group of men dressing on the left-hand side of *Baptism* (no.47), sensitive atmospheric effects such as the glowing light around the man with a candle kneeling in the foreground of *Extreme Unction* (no.40), imposing

figure groups such as the priest and his acolyte in *Confirmation* (no.41), are all orchestrated to clarify the narrative and lend significance to the drama, without ever undermining the overall coherence of the invention which Poussin, with unwavering single-mindedness, imposed upon each picture in the sequence. This sense of unity within the series extends to the handling and technique. All the paintings are executed on the same dark ground, and have the same sombre tonality, penetrating lighting and precise even handling. This achievement seems all the more remarkable when it is remembered that Poussin despatched each picture in the series to Paris as soon as he had completed it, and therefore never saw all seven Sacraments together.

For Chantelou the overall effect was perhaps too forbiddingly uniform. When Bernini visited Paris and saw the collection in 1665 he found that each of the Sacraments was covered with a curtain, so that the spectator could concentrate on one painting at a time, without distraction from the others. Such pictures, crystallizing the aspirations and emotions of the human spirit at some of the most critical stages of human life, require sympathetic and thoughtful contemplation and an intimate answering space. For here Poussin unquestionably demands of his audience some measure of the mental concentration, emotional control, historical imagination, and stoical faith that he himself had learned, by rigorous self-discipline, to apply to the masterpieces of his maturity.

(HB)

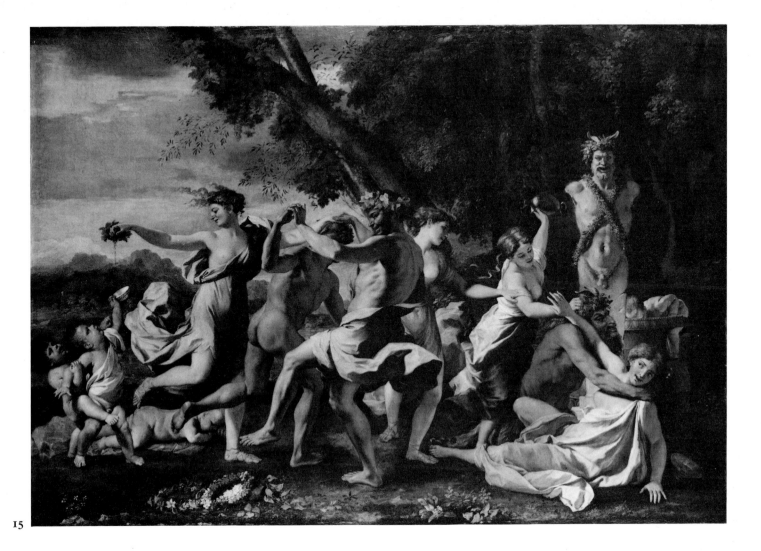

15

15

Bacchanalian revel before a herm of Pan

Oil on canvas; 100×142·5cm

X-rays show signs of another painting
underneath, upside-down, but the general
design is not clear and the subject has not
been identified. The subject is traditionally
described as a revel before a herm of Pan
but, as Blunt points out (1967, p.144), the
prominent floral wreaths in the foreground,
combined with the elaborate floral
decoration of the herm, might suggest an
allusion to Priapus, the god of gardens and

fertility, instead. A similar ambiguity
surrounds the subject matter of no.18,
generally identified as *The Triumph of Pan*.
Both pictures were probably designed at
about the same time, since the motif of the
putto drinking on the right of the
Bacchanalian revel occurs also in one of the
earlier preparatory drawings (no.20) for
Richelieu's *Triumph of Pan* which was
delivered in 1636. The central motif of the
present picture is the imposing classical
group of dancers. They appear again in
Poussin's *Adoration of the Golden Calf* in the
National Gallery, London (perhaps datable
shortly after the Dresden *Adoration of the
Magi* of 1633, and also close in style to the

Saving of Pyrrhus in the Louvre,
documented 1634). The dancers may have
been inspired by an engraving by Zoan
Andrea after Mantegna (fig.7). The emphatic
movements and strong sculptural
modelling of the figures, the firm contours
of the crisp draperies, and the clear
colouring all confirm the impression,
traceable in the first instance to the Dulwich
Triumph of David (no.13), that by the early
1630s Poussin had finally abandoned his
romantic Venetian manner in favour of a
classical style, based on the example of
Renaissance design and antique sculpture.
The large-scale, highly finished,
preparatory drawing for this picture

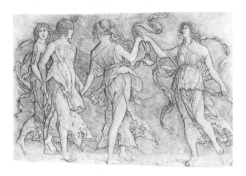

(no.17), like the cartoon at Chantilly for the three foreground figures in the Dulwich picture, underlines Poussin's new preoccupation with the precise rendering of human forms and of the intervals and spaces between them.

coll: Randon de Boisset sale, Paris 1777, bought Lebrun; Calonne sale, London 1795; Bryan's Gallery, London 1795; Rev. Frederick Hamilton; William Troward; Lord Kinnaird; Delahante; Thomas Hamlet who sold it to the National Gallery, London in 1826

exh: Paris 1960, no.50

ref: Blunt 1966, no.141

The Trustees of the National Gallery, London

16

Dance before a herm of Pan

Pen and bistre wash; 208×327mm

Although in style the drawing is of the 1620s and thus predates the painting in the National Gallery by almost a decade, all the essential elements in the latter are present here (a round dance, the satyr attacking a nymph, the herm of Pan), but rearranged.

coll: from Cardinal Massimi's album of Poussin drawings which was acquired by Frederick, Prince of Wales – possibly from Dr Mead, who may have bought it when in Rome during 1695–6. (See Blunt, *Master Drawings,* XIV, 1976, pp.3ff)

exh: Bologna, 1962, no.181

ref: Blunt, *French Drawings,* no.174, pl.29; *CR,* III, no.196, pl.152; Blunt, *Drawings,* pl.111

Her Majesty The Queen (Windsor 11979)

17

Dance before a herm of Pan

Black chalk, with bistre and red wash. Squared for transfer in red chalk; 234×341mm (irregularly cut)

In scale and finish the drawing is unique in Poussin's output. It represents the ultimate stage in preparation and from it the design would have been transferred directly to the canvas. The figures are approximately one quarter of the size of those in the painting (no.15) and differ from them in certain details. In the latter for example the nymph on the left squeezes out a bunch of grapes instead of pouring from a jug, as she does in the drawing.

coll: Sir Peter Lely

ref: CR, III, no.198, pl.154; Blunt, *Drawings,* pl.112

The Trustees of the British Museum (Sloane 5237–147)

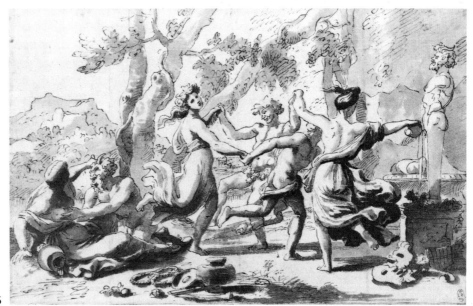

16

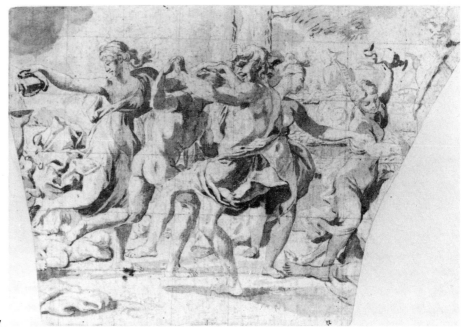

17

The Triumph of Pan

Oil on canvas; 134×145cm

The picture was commissioned by Cardinal Richelieu, together with *The Triumph of Bacchus* (no.24), which is of identical format. They were required to complete the decoration of a room which was to contain a series of paintings by Mantegna, Costa and Perugino (now Musée du Louvre) from the studiolo of Isabella d'Este in Mantua, which had been presented to Richelieu. Poussin's pictures were despatched from Rome in May 1636. In view of the exceptional importance of the commission they were presumably executed, without undue delay, during 1635 and the early months of 1636. There is some uncertainty as to whether the picture represents the Triumph of Pan, god of the pastures, especially of sheep and goats, who is associated with the development of the Arcadian fertility cult, and who was the chosen lover of the maenads during their drunken orgies on the high mountains, or else the Triumph of Priapus, the god of gardens and fertility. The herm's red face is equally applicable to Pan and Priapus; red dye (lake), made from boiling a liquid taken from ivy stems, and mixed with urine, was widely used to colour the faces of male fertility images. It may be significant that the starting point for Poussin's final design was an engraving by the Master of the Die, after Giulio Romano, *The Sacrifice to Priapus*

(fig.8). Several features from this engraving are identifiable in the present painting: the central position of the herm, the motif of a nymph decorating the herm with flowers, and the figure of the trumpeter on the extreme left. The bacchanalian paraphernalia, in the foreground, are based on copies, made by Poussin and other artists in Cassiano dal Pozzo's antiquarian circle, from ancient reliefs of Bacchic ceremonies. There are the pipes and bent stick associated with Pan; thyrsoi (staves wrapped in grapevines and crowned with pine cones), which were traditionally carried by Bacchus and his votaries (cf. also no.24); tambourines; antique vases; and tragic, comic, and satirical masks, emphasizing the Bacchic origin of the Attic drama. The frieze of trees which forms a backcloth to the design is clearly inspired by the background of the Bellini/Titian *Feast of the Gods* then in the Aldobrandini collection (see no.6). However the presence of vines, growing among the marvellous foliage along the top of the design, suggests that Poussin was also influenced here by his knowledge of ancient vases on Bacchic subjects, which are often decorated with vine leaves in this manner. Poussin's treatment of the foliage is close in style to that in the *Bacchanalian revel before a herm of Pan* (no.15). *The Triumph of Pan*, like the *Bacchanalian revel before a herm of Pan* is essentially an impressive exercise in formal abstract design, only here the composition is tighter, closer to an antique bas-relief than to sculpture in the round. The figures

and groups have no dramatic or psychological relationship, and the preparatory drawings show Poussin freely redeploying some motifs, such as the female sitting astride a goat, before he finally arrived at a definitive and highly formalized solution. The general tonality of the picture is extremely bright and sharp. The handling of the draperies is particularly vivid and imaginative, both in form and colour. The dress of the female figure decorating the herm is composed of two quite separate colours, blue and peach pink, which are juxtaposed with delicate precision. A similar and equally effective juxtaposition of orange and pink characterizes the elaborate geometric forms of the robe worn by the female holding a tambourine, on the extreme right. Even the inert mass of white drapery lying in the foreground of the picture is cleverly arranged and modelled to suggest the outline of a non-existent human figure. Yet, underlying all the visual ornamentation and the exuberant revelry, there is a more serious intention. These rites are religious ceremonies in honour of a pagan god. As such they complement the early Christian ceremonies celebrated in the first series of Sacraments, some of which were probably first conceived at about the same moment.

coll: Cardinal Richelieu collection at the Château de Richelieu in Poitou in France; by descent to the Cardinal's great nephew, Armand Jean de Vignerod du Plessis, Duc de Richelieu; sold during the 18th century and replaced by a copy, now in the Musée des Beaux-Arts, Tours; first recorded in Britain at the Samuel Paris sale 1741–2, and bought by Peter Delmé; Delmé sale, Christie's, London, 1790 bought Lord Ashburnham; Ashburnham sale 1850, bought by Hume for James Morrison; by descent to the present owners

exh: Paris 1960, no.45

ref: Blunt 1966, no.136

The Trustees of the Walter Morrison Pictures Settlement, from Sudeley Castle

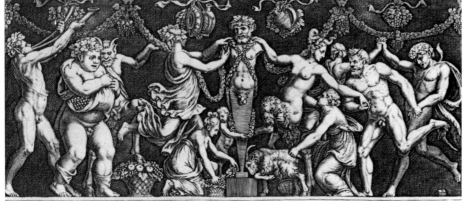

Quanto honorato sei benigno bacco.
Il becco el satir quil dimoſtra e' quelli
Ch'an del mo buon liquore' empito l'sacco Philippus Thomaſſinus excudit Romæ
Soſtegni di Silen tutti e' fratelli Gio. Iacomo deRoſſi la ſtampa in Roma alla Pace.

Comuni in allegrezza, e' quel ch'e' ſtracco
Di ber, ſatio non e' doue con belli
Modi, e'con atti alla tua ſtatua intorno
Feſtegia ognun dele ſue fronde adorno.

Fig.8
Master of the Die, after Giulio Romano

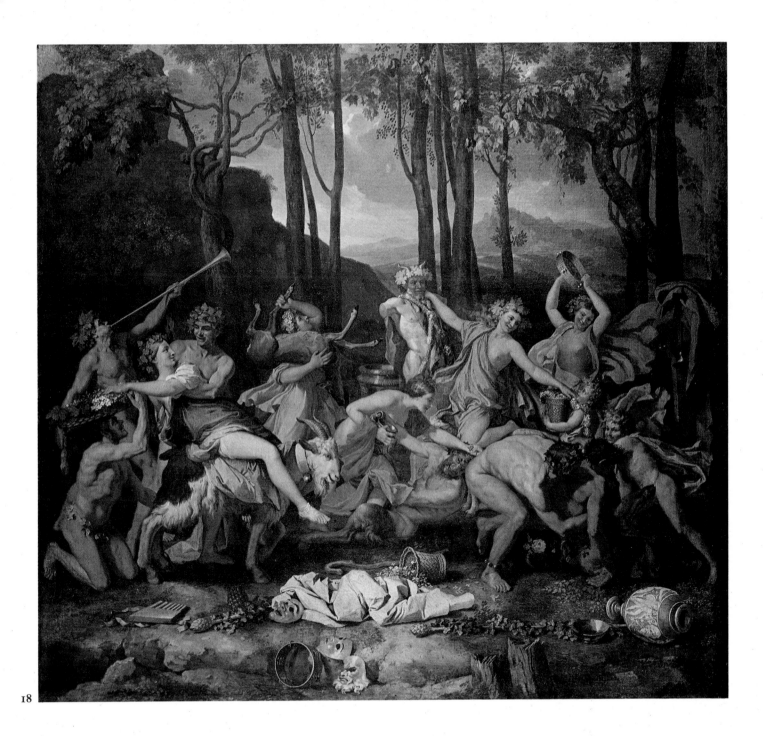

18

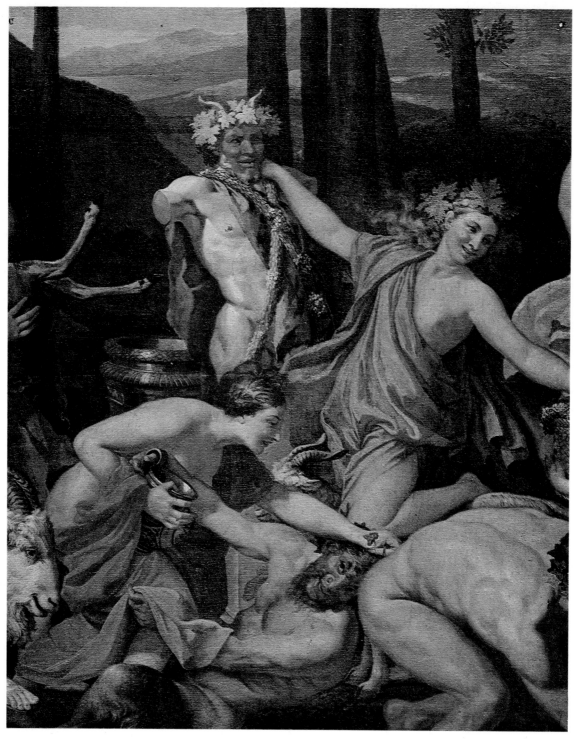

18 (detail)

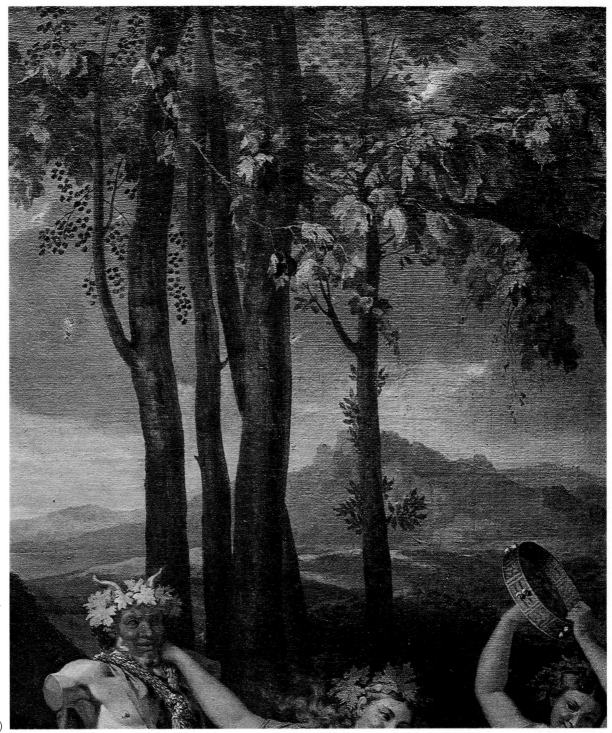

18 (detail)

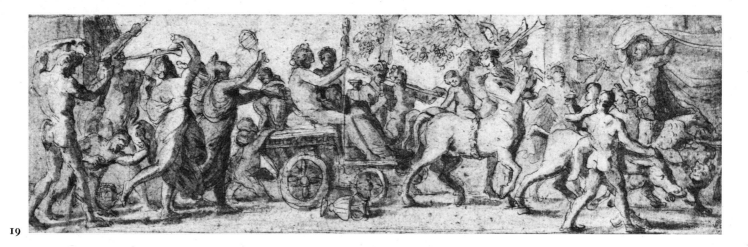

19

19

The Triumph of Bacchus and Ariadne

Pen and grey wash over red chalk;
125×413mm

This drawing dates from the later 1620s and
is included here as an early example of
Poussin's treatment of a bacchanalian
theme which he was to develop in the
pictures he painted for Cardinal Richelieu
during the following decade.

coll: from Cardinal Massimi's album of
Poussin drawings – see no.16

ref: Blunt, *French Drawings,* no.172; *CR,* III,
no.183, pl.147; Blunt, *Drawings,* pl.114

Her Majesty The Queen (Windsor 11990)

20

Bacchanal

Pen and bistre wash over black chalk;
129×207mm

The drawings that survive for the *Triumph
of Pan,* more than for most pictures by
Poussin, record the various stages reached
by the artist to achieve the most effective
composition with the various elements that
comprise it. They are: the herm of Pan

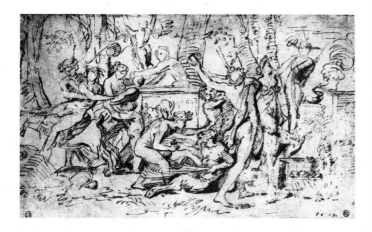

Fig.9 (not exhibited)
Musée Bonnat, Bayonne

Fig.10 (not exhibited)
Musée Bonnat, Bayonne

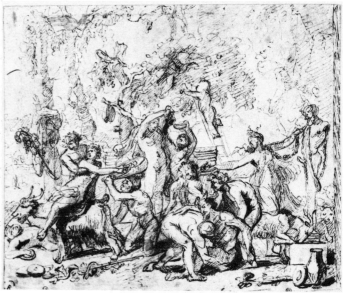

being decked with garlands by a girl; a girl riding a goat and supported from behind by a satyr; two youths attempting to lift a drunken faun; a struggle between a nymph and a satyr; a maenad carrying a faun (or calf) on her shoulder; and a corybant blowing a trumpet. This is the earliest drawing in the series and is followed by studies at Bayonne (*CR,* III, nos.186 and 187), figs.9 and 10.

exh: Florence, Uffizi, *Mostra di disegni francesi da Callot a Ingres,* 1968, no.11, fig.12

ref: CR, III, no.193, pl.150

Gabinetto Disegni e Stampe degli Uffizi, Florence (905E)

21

Studies of a Bacchante decorating a herm

Pen and bistre; 149×218mm

The principal development of the composition reflects the change in the original conception of the picture as that of an ordinary Bacchanal with the herm of Pan occupying a subsidiary position on the right, into a specific Feast or Triumph of Pan with the herm as the pivotal point of the design. This drawing contains studies for the Bacchante as she appears on the right of the original composition, e.g. in the Bayonne drawings (figs.9 and 10). The figure on the left of the sheet is a study for the mourning women on the left of *Extreme Unction* (no.33), from the first set of Sacraments.

coll: from the second volume of Poussin drawings at Windsor. The contents almost certainly belonged to Cassiano dal Pozzo from whose heir they were bought by Pope Clement XI, uncle of Cardinal Albani to whom the volume later belonged, and from whom it was acquired for George III by James Adam in 1762

ref: Blunt, *French Drawings,* no.219 *verso*; *CR,* III, no.188, pl.151; and V, p.90; Blunt, *Drawings,* pl.37

Her Majesty The Queen (Windsor 11902 *v*)

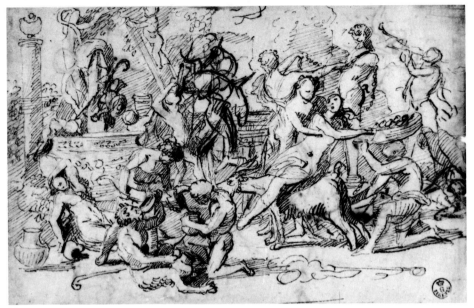
20

21

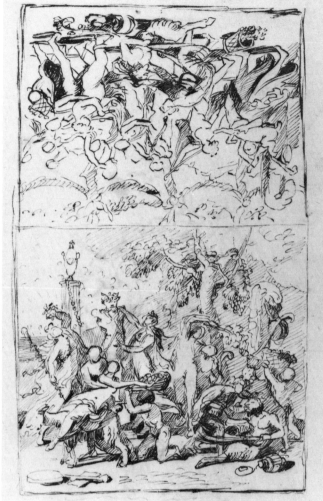

22a

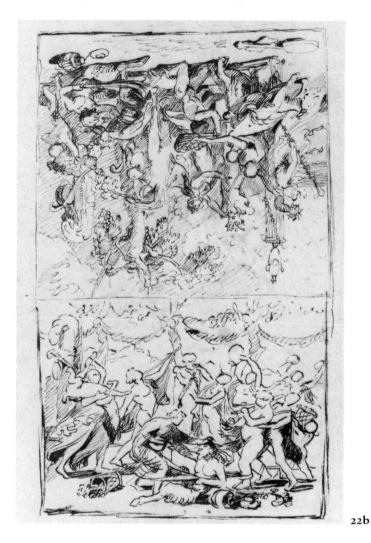

22b

Fig. 11 (not exhibited)
Musée Bonnat, Bayonne

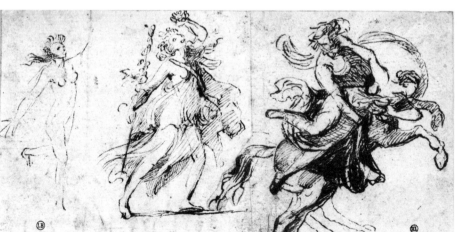

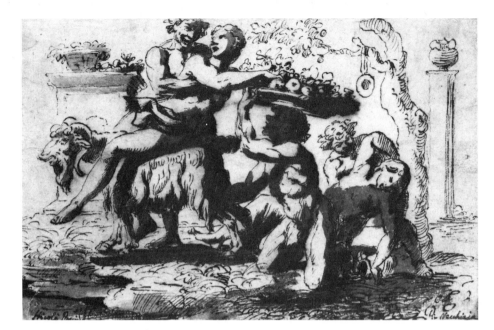

22

Dance in honour of Pan

Pen and bistre; 313×201mm

The design on the lower half of the sheet shows the herm of Pan almost in the centre. The maenad on the left who does not appear in the painting is the subject of separate studies on a drawing in Bayonne (*CR, III*, no.191), fig.11. The girl on a goat still appears in the reverse position, as she does in the drawing belonging to Miss Isabella Baer (*CR, V*, no.438), fig.12.

The sketch upside-down on the top of the sheet (pl.22b) introduces for the first time the maenad carrying a faun (or calf) and the corybant. The herm is now in the centre, and much the same arrangement is sketched in the lower-right corner of another drawing at Bayonne (*CR, III*, no.190),

Fig. 14 *Verso* of no.20

fig. 13. Elements in the design appear on the *verso* of the Uffizi drawing, no.20 above (fig.14).

coll: from Cardinal Massimi's album of Poussin drawings – see no.16

ref: Blunt, *French Drawings*, no.199 *verso*, pl.47; *CR*, III, no.189, pl.148; Blunt, *Drawings*, p.104, pl.118

Her Majesty The Queen (Windsor 11905 *v*)

23

The Triumph of Pan

Pen and bistre wash; 229×335mm

The composition almost as it is in the painting, without the elaborate still-life in the foreground and with the design closed at the top by a kind of vine trellis. The lighting, achieved by a masterly handling of the wash, is particularly vivid.

coll: from Cardinal Massimi's album of Poussin's drawings – see no.16

exh: Paris, 1960, no.141; Bologna 1962, no.182

ref: Blunt, *French Drawings*, no.200; *CR*, III, no.192, pl.152; Blunt, *Drawings*, p.104, pl.119; R. Verdi, *Burlington Magazine*, CXXII, 1980, p.588

Her Majesty The Queen (Windsor 11995)

24

The Triumph of Bacchus

Oil on canvas; 128·5×151cm

Bacchus, the god of wine, was usually accompanied by satyrs and maenads (frenzied women) who would abandon themselves to wild dances, dressed in skins, carrying torches and armed with thyrsoi (staves wrapped in grapevines and crowned with pine cones), swords, and serpents. The god's entourage includes Pan with his pipes, Silenus holding a branch from a vine, and Hercules carrying a tripod he stole from Apollo, who is seen in the sky driving his chariot. There is a river god in the foreground (see further Blunt 1967, pp.141f). Poussin's *Triumph of Bacchus* was commissioned by Cardinal Richelieu as companion to *The Triumph of Pan* (no.18); both pictures were delivered in 1636 and they were probably planned and executed at the same time. Drawings in the Uffizi (no.20; see also fig.14) and at Windsor (no.22; see also fig.15) contain studies for

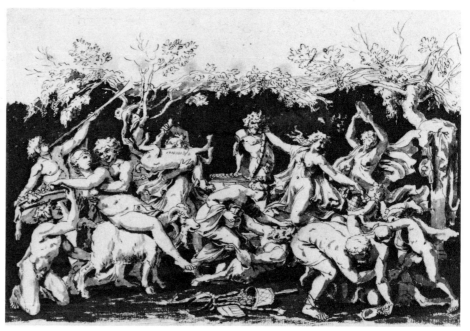

23

both pictures. The two pictures apparently remained together until the 19th century when they were sold out of the Ashburnham collection. However, since 1925, when the Kansas City picture was exhibited in Paris, an idea that it might be a copy of a lost original gained credence; and it was catalogued as such by Blunt in 1966. In 1977 Pierre Rosenberg (Rome exhibition catalogue) argued that it should be reinstated as an original, explaining that the relatively dry quality of the execution should be interpreted as a conscious effort by the artist to eschew distracting effects of virtuosity (but cf. A. Blunt, *Burlington Magazine*, CXX, 1978, p.422, as an authentic work, executed with the help of studio assistants; and E. Schleier, *Kunstchronik*, 31, 1978, pp.274ff, as a copy). Direct comparison in this exhibition between *The Triumph of Bacchus* and the recently cleaned and well preserved *Triumph of Pan* (no.18) should finally lead to a resolution of this issue. Allowance must however be made for the present condition of the Kansas City picture, a question which has not been adequately aired. Although not affected by serious external damages, the picture appears to have been overcleaned (there is

no record of it having been cleaned while at Kansas City) affecting the overall tonality and resulting in some paint loss, which affects the relationship of the closely knit forms, and deprives us of the subtle but easily disturbed modelling and extremely delicate painterly effects that distinguish *The Triumph of Pan* (no.18) and *The Triumph of Neptune* (no.27). On balance it seems likely that *The Triumph of Bacchus* is an original. It is difficult to imagine any copyist achieving the vigour of the centaur holding a torch and flowers, the warmth of the landscape background under a golden sky, or the subtle and lively handling of the ivy, vine leaves, and other foliage which surrounds and decorates the foreground figures. At the same time, condition alone cannot explain the extremely poor modelling of certain figures, most notably the putto in the left foreground and the dancing female, seen from behind, at the extreme right. The picture's high tonality and the strong local colours are consistent with *The Triumph of Pan* (no.18), but without the subtle juxtapositions of hue in the treatment of individual draperies which lend particular distinction to the Sudely picture.

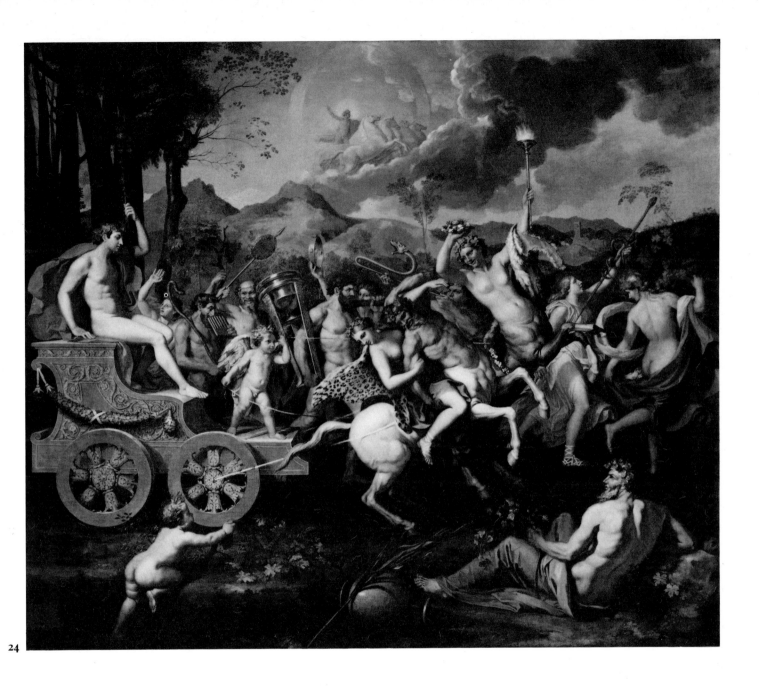

24

coll: for the history of the picture up to the time of the Ashburnham sale 1850 see no.18; bought Lord Carlisle and by descent to the Hon. Geoffrey Howard; bought 1932 by the William Rockhill Nelson Gallery of Art–Atkins Museum of Fine Arts

exh: Le paysage français, Petit Palais, Paris 1925 (271); Rome 1977 (22)

ref: Blunt 1966, no.137

Nelson Gallery–Atkins Museum (Nelson Fund), Kansas City, Missouri, USA

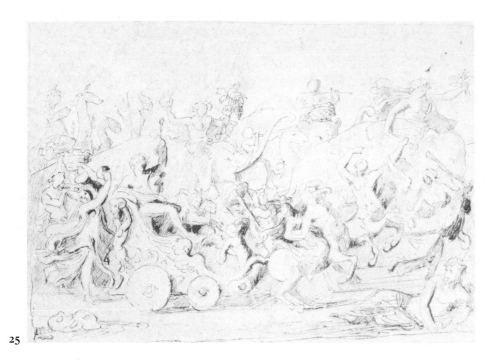

25

The Indian Triumph of Bacchus

Pen and bistre; 159×229mm

A drawing at Windsor (fig.15) which has studies for *The Triumph of Pan* (no.18) on the back of it (no.22) is the earliest study for the Kansas painting. The main difference between the Windsor sheet and the present one is that the diagonal movement of the procession in the former is here substituted for a more classical, frieze-like arrangement. In both drawings however, Bacchus, accompanied by a variety of animals, is represented as conqueror of India. There exist three fragmentary studies for the centaurs (*CR,* v, nos. 435–435A, 437).

coll: Maurice Marignane

ref: CR, v, no.436, pl.312; Blunt, *Drawings,* pl.116

Nelson Gallery–Atkins Museum (Nelson Fund), Kansas City, Missouri, USA

After Nicolas Poussin

26

The Triumph of Silenus

Oil on canvas; 143·5×121cm

In addition to *The Triumph of Pan* (no.18) and *The Triumph of Bacchus* (no.24), painted by Poussin for Cardinal Richelieu and despatched in 1636, a third *Triumph* by Poussin is recorded in the Richelieu collection in 1646 (C. H. Van den Berg, *Oudheidkundig Jaarboek,* XI, 1942, p.16). This was described as a *Banquet of Silenus* by J. Vignier (*Le Chasteau de Richelieu,* 1676, pp.165f). A *Triumph of Silenus* is among three copies in the Musée des Beaux-Arts, Tours, which replaced original works attributed to Poussin when they were sold out of the Richelieu collection in the 18th century. An original painting by Poussin of *The Triumph of Silenus* has yet to be traced. The present picture, similar in design to the copy at Tours, and traceable only to the 19th century, is clearly not an original work by Poussin and is exhibited here for the sake of its design. No preparatory drawings by Poussin have been recorded, but many of the motifs from the present picture appear to have been taken over from the other two Richelieu Bacchanals or from preparatory studies connected with them. The figure of Silenus, tutor of Bacchus and a conventional comic character in the Attic

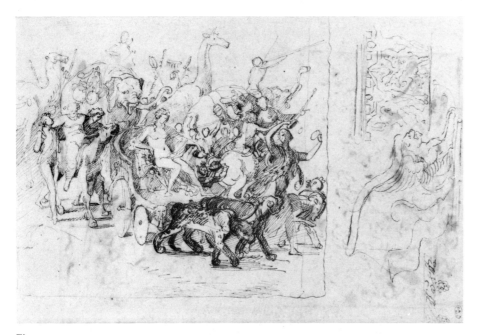

Fig.15
Recto of no.22

26

drama, is an adaptation from a group on the left-hand side of an early preparatory drawing at Windsor for *The Triumph of Bacchus* (fig. 15), except that in this drawing he is shown on a donkey, whereas in the painting he is represented in a drunken sprawl, with one leg astride a tiger. A rather similar figure of a drunken Silenus also occurs twice on a sheet of studies at Bayonne which also includes (*recto* and *verso*) two compositional studies for *The Triumph of Pan* (fig. 13). The scene in the background, involving the torture and misuse of a donkey, does not occur elsewhere in Poussin's work; but the motif of a man carrying off a woman mounted on a goat is traceable to *The Triumph of Pan* and the preparatory drawings connected with it. These formal links with the two other Richelieu Bacchanals could be interpreted as suggesting that *The Triumph of Silenus* was conceived at around the same moment. On the other hand its design lacks the impressive integration of human forms that characterizes the other two pictures; and it also seems rather surprising that Poussin should have repeated himself, in so obvious a manner, especially when the same collector was involved. Such considerations explain the suspicion, first raised by Martin Davies (*National Gallery Catalogue: French School*, London 1957, pp. 187ff) that *The Triumph of Silenus* could be a later pastiche of Poussin's style, although Davies finally came down in favour of Poussin's authorship of the design. The design is also attributed to Poussin by Blunt. This still seems the most convincing solution. The picture's high tonality; the strongly directed lighting originating from a source outside the picture, to the left; the distinctive local colours of the draperies, and their elaborate forms; the sensitive treatment of the sky, and the screen of trees silhouetted against the sunset; are all inventive qualities consistent with Poussin's style in *The Triumph of Pan* (no. 18) and *The Triumph of Bacchus* (no. 24).

coll: in the collection of J. Angerstein by 1809; purchased with the rest of his collection by the National Gallery, London 1824

ref: Blunt 1966, no. 138

The Trustees of the National Gallery, London

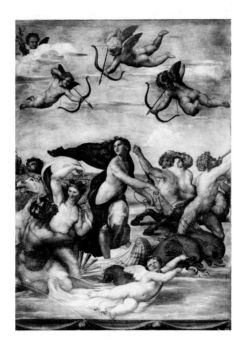

Fig. 16
Villa Farnesina, Rome

27

The Triumph of Neptune

Oil on canvas; 114·5×146·6cm

Considerable controversy surrounds the identification of the female goddess. She might be Venus, landing at Cyprus, and greeted by a festive gathering of marine deities. Alternatively she could be Amphitrite, a nereid who was loved by Neptune, but fled from him to the furthest point of the ocean, where she was traced by the dolphin and was persuaded to succumb to her suitor (see R. Simon, *Art Bulletin*, LVIII, March 1978, p. 65, and in particular n. 60 for summary of the previous literature). The overall design of the picture was clearly inspired by Raphael's fresco of the *Triumph of Galatea* in the Villa Farnesina (fig. 16). The female figure on the right, seen from behind, derives from Raphael's *Marriage of Cupid and Psyche* (fig. 17). However Raphael's High Renaissance aesthetic, his capacity to convey a sense of dynamic physical force suspended, almost miraculously, in harmonious equilibrium, is replaced here by a much more static, elaborate and intricate design. The figures and draperies are tightly modelled through the subtlest nuances of delicate and meticulous brushwork, thinly and evenly applied, with subtle variations of tone, the minimum of chiaroscuro, and without the sculptural emphasis on three-dimensional form which characterizes the *Bacchanalian revel before a herm of Pan* (no. 15). It seems likely that Poussin was consciously emulating the flat even-toned effect of antique wall paintings. The picture is generally identified as *The Triumph of Neptune,* described by Bellori (p. 437) and Félibien (IV, p. 27) as having been painted for Cardinal Richelieu, but its connection with the other Bacchanals painted for the Château de Richelieu and delivered in 1636 (nos. 18 and 24) is not established. Nevertheless it seems reasonable, on stylistic grounds, to place the *Triumph of Neptune* in the mid-1630s.

coll: Cardinal Richelieu; Fromont de Brevannes by 1700; Louis Antoine Crozat, Baron de Thiers 1755; sold with the whole Crozat de Thiers collection to the Empress Catherine II of Russia 1771; sold by the Russian Government, and then acquired by the Philadelphia Museum of Art, 1932

exh: Paris 1960, no. 47

ref: Blunt 1966, no. 167

Philadelphia Museum of Art (The George W. Elkins Collection)

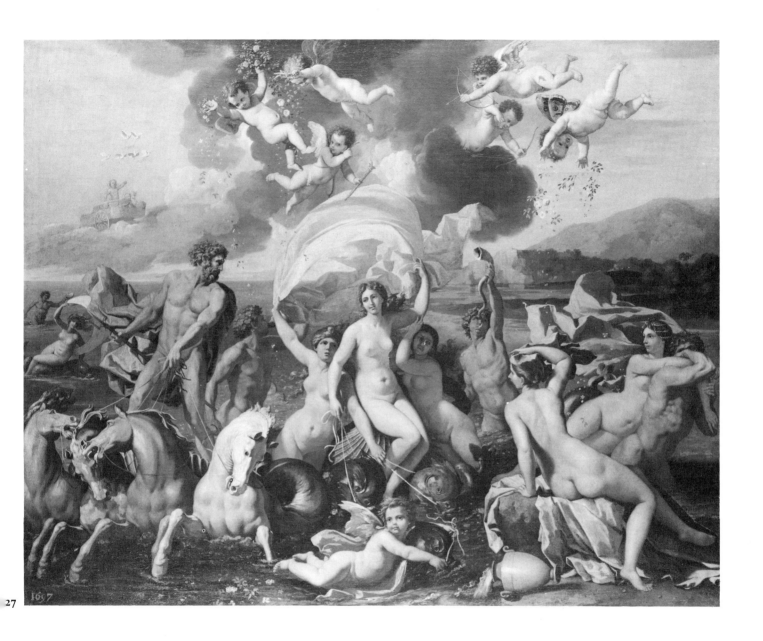

27

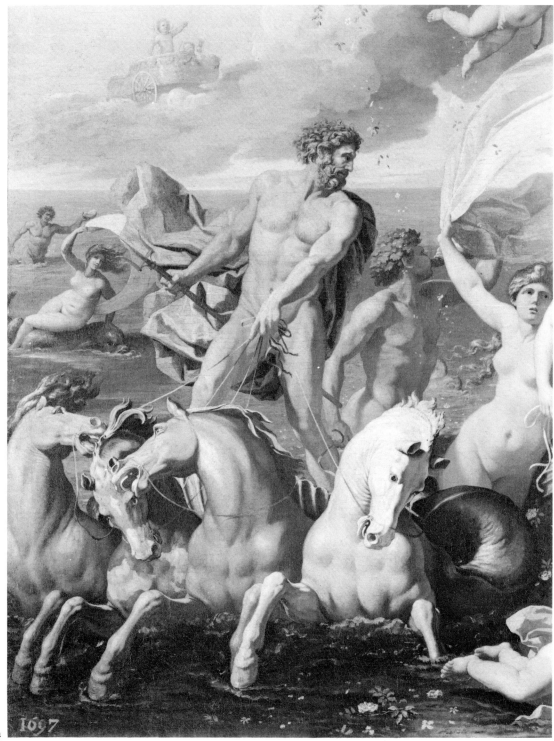

27a

Fig. 17 Villa Farnesina, Rome

28

Moses striking the rock

Oil on canvas; 98·5 × 136cm

Moses strikes the rock to produce water for the Israelites in the wilderness (*Exodus* 17). Almost certainly the version of this subject painted, according to Félibien, for Melchior Gillier, a Parisian collector who had visited Rome in the early 1630s. Félibien (IV, p.24) indicates a date around 1635–37. This would be consistent with the decorative treatment of the landscape. the delicately observed foliage silhouetted against an open sky, which is close to that of *St John baptizing the people* in the Louvre (no.30) and *Ordination* from the first series of Sacraments (no.31). The principal difference between the *Moses striking the rock* and the above-mentioned pictures lies in the arrangement and characterization of the figures. Whereas the figures in *Ordination* and *St John baptizing the people* are essentially passive and physically inert, those in the *Moses* reflect Poussin's interest in Leonardo da Vinci's observations on the connection between physical movement and inward emotions and mental attitudes. In the *Moses* more

effort is made to place the subsidiary figures in depth by progressively reducing their scale as they recede into the background; and the landscape is also used to reinforce the effect of recession, the tree trunks establishing the spatial relationship of the figures. During the 1630s, adherents of classical art-theory were criticized in the debates at the Accademia di San Luca (of which Poussin was a member) for their failure to give variety and depth to their designs, and for the avoidance of subjects requiring crowded compositions. In this picture Poussin meets such objections, without in any way compromising the basic principles of classical design.

coll: Melchior Gillier; de l'Isle Sourdière; the Président de Bellièvre; Dreux; Jean-Baptiste Colbert, Marquis de Seignelay; Duc d'Orléans by 1727; imported to Britain by Bryan 1798 and reserved for the Duke of Bridgewater; thence by inheritance, Bridgewater House, no.62

ref: Blunt 1966, no.22

Duke of Sutherland (on loan to the National Gallery of Scotland)

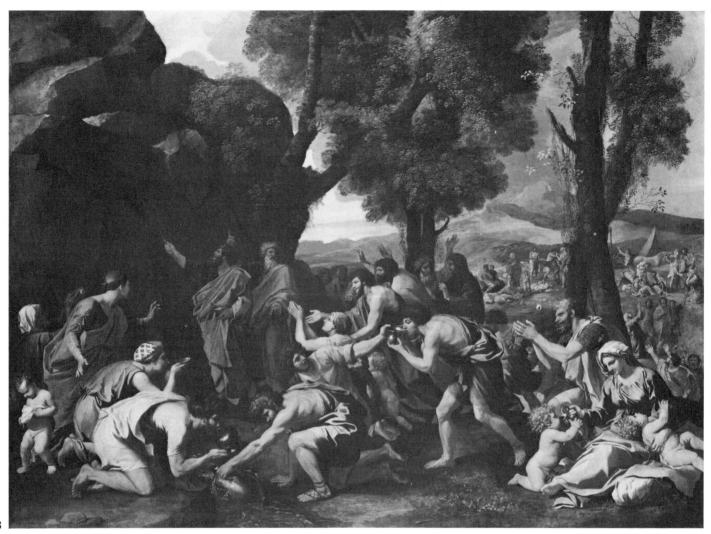

28

29

Moses striking the rock

Pen and bistre wash; 241×370mm

The only study for the painting which follows the composition in all essentials. In the picture, however, Poussin reduced the size of the figures in relation to the landscape and explored the middle distance and background which is treated as a backdrop in the drawing.

coll: Robert de Cotte

exh: Paris 1960, no.155

ref: CR, I, no.23, pl.14; Blunt, *Drawings,* pl.41

Cabinet des Dessins, Musée du Louvre, Paris (32431)

30

St John baptizing the people

Oil on canvas; 94×120cm

The scene is the bank of the River Jordan. The arrangement of the figures within a narrow plane in the foreground, against a sharply observed light-toned landscape background, notable for the feathery handling of foliage and of the hills behind, suggests that this picture probably dates *c.*1635–36, about the same time as the *Ordination* (no.31) from the first series of Sacraments, and the *Moses striking the rock* (no.28). Mahon (Bologna exhibition catalogue, 1962) and Jaffé (in *Etudes d'Art Français offertes à Charles Sterling,* 1975, pp.215–16) have argued convincingly that Poussin may have been inspired in this picture by the elegance of Guido Reni's fresco of *St Andrew led to martyrdom* (fig.18) in the Oratory of St Andrew, attached to the church of San Gregorio in Celio in Rome, rather than by the more schematic and classically resolved design of Domenichino's fresco on the opposite wall, which according to Bellori (p.427) Poussin had preferred and which had certainly already influenced him when he designed the Dulwich *Triumph of David* (no.13). The motifs of the horseman, on the left, and of the woman holding her child, on the right, are both closely dependent on Reni's invention; and there is a sense of movement among the overlapping human figures which is much closer to the aesthetic of Reni's crowded but shallow composition than to any of Domenichino's narrative fresco cycles.

29

coll: André Le Nôtre by 1685; given by him to Louis XIV in 1693

exh: Paris 1960, no.55; Rouen 1961, no.80; Bologna 1962, no.61

ref: Blunt 1966, no.69

Musée du Louvre, Paris

Fig.18
Oratory of St Andrew, San Gregorio in Celio, Rome

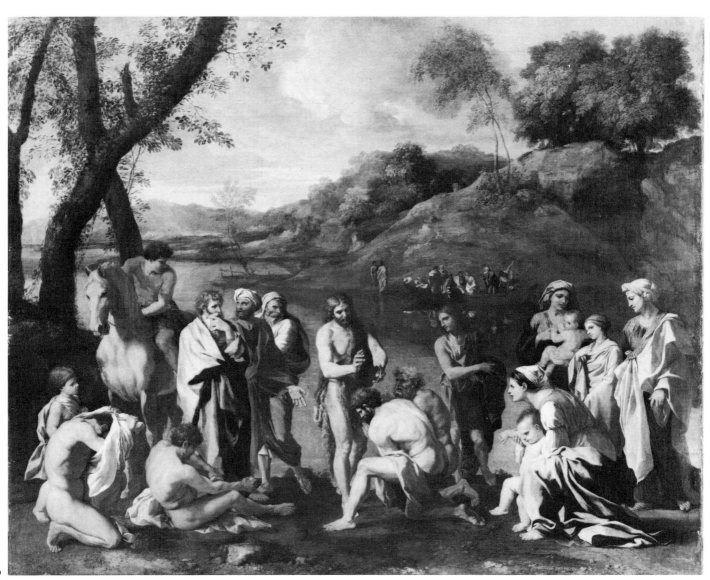

30

The Iconography of Poussin's Sacraments

It is indeed appropriate that Poussin's two series of Sacraments should have been chosen as the centre-piece of this exhibition, for of all his religious works, perhaps none is more strikingly original in conception. To paint the sacraments at all was an exceptional undertaking for a seventeenth-century painter in Rome: only one painted sacrament cycle is known in Italy before Poussin (i.e. Roberto Oderisi's fresco cycle in S.M. Incoronata, Naples), and the theme, while slightly more common in the North, never became popular in Catholic Europe. It is chiefly found in fifteenth- and sixteenth-century English octagonal fonts, and sixteenth-century Flemish and German engravings. The practice in all these examples since the fourteenth century had been to show the sacraments as celebrated in contemporary ecclesiastical usage, the people in the dress of the artist's period shown receiving the sacrament from a vested priest or bishop. Invariably the seven scenes are integrated into a single multiple composition, such as, for example, in Rogier van der Weyden's famous 'Sacraments' altarpiece at Antwerp: the Crucifixion on the central panel of the triptych, with Mass being said in the background, and the other six sacraments being depicted on the wings.

The idea of executing seven *separate* monumental images of the seven sacraments for a private patron is quite unprecedented. But more importantly, in these canvases, Poussin makes a radical break with earlier tradition, by attempting to situate the sacraments no longer in the church life of their own time, but in the world of early Christian antiquity. In both series, but especially in the second, all is strictly conceived according to severely classical norms: heads, draperies, architecture, everything is based on carefully researched antique models. In using Roman dress and settings, Poussin is making 'a deliberate effort to represent the subjects in conformity with the practice of the Early Church, a project apparently without parallel at the time' (Blunt).

As far as possible, Poussin has attempted to depict the institution or prototype of each sacrament as found in the New Testament. Four sacraments, accordingly, are shown as events in the life of Christ, and for a fifth (marriage) he paints the Marriage of the Virgin, as narrated in the

apocryphal New Testament tradition. The evangelical scenes are: the Baptism of Christ, the supper in the house of Simon the Pharisee, Christ giving the keys to Peter, and the Last Supper, representing respectively the sacraments of baptism, penance, ordination and eucharist. All these New Testament scenes had frequently been painted before, and by and large, Poussin's rendering of them does not depart from time-honoured tradition. Iconographic innovation is limited to the occasional detail, such as the alleged 'philosophers' grove' or the 'E' on the column in *Ordination II* (no. 53). What is new is not the composition of individual scenes, but the grouping of them precisely as a coherent sacrament series.

However, in *Unction* and *Confirmation,* Poussin moves from the Gospel narratives to liturgical events in the life of the primitive Church. Concerning *Unction,* the artist had little choice, for although the anointing of the sick is prescribed by St James (v. 14), the actual enactment of the rite is never described in the New Testament. In the case of *Confirmation* an obvious Biblical source was to hand, the accounts in *Acts* (viii. 17) of the Apostles Peter and John laying hands on the newly-baptised. One can only suppose that Poussin departed from his practice of preferring a New Testament prototype because he (or his patron) was aware of the unusual opportunities of displaying antiquarian erudition in the depiction of the scene in an early Christian context. At any rate, the iconography of *Confirmation* is unprecedented: here Poussin brings the liturgical life of the Early Church to life before our eyes, conveying the religious solemnity of the scene in a manner at once entirely original and historically authentic.

The times were ripe for such an exercise in palæochristian reconstruction. The Council of Trent had led to a lively renascence of interest in the thought and culture of early Christianity, and Catholic reformers were looking to the writings of the early Fathers and the ancient liturgies as models of purity of life and doctrine, against which contemporary theology, and especially sacramental practice, could be measured. There was no lack of philosophical and erudite churchmen in Poussin's circle – such as Holstenius or Cardinal Massimi – who could guide him to the appropriate patristic sources in their libraries.

The lifetime of Poussin also saw the first beginnings of serious Christian archaeology (especially the investigation of the Roman catacombs) and connoisseurs were beginning to collect late antique Christian funerary reliefs, as well as classical marbles. Foremost among the Roman patrons of the day was the learned Cassiano del Pozzo who commissioned the first series. Interested in antiquities more as clues to the scientific reconstruction of the past, rather than simply as art-objects, Pozzo amassed a gigantic and carefully arranged 'paper museum' of drawings of all the available vestiges of ancient Rome. This collection was of inestimable value to painters like

his chief *protégé,* Poussin, who were seeking authentic settings and detail for their work.

The exactitude of antiquarian reconstruction in the Sacraments can best be illustrated by selecting some particular points of iconographic interest in the pictures.

Starting with *Penance* (no. 52) we see the penitent woman standing behind Christ (exactly following the words of Luke, vii. 38) and anointing His feet at the supper in the house of Simon the Pharisee. The Gospel account only makes sense if one envisages Christ reclining at table, His legs pointing outwards. Hence the introduction of the *triclinium,* the sigma-shaped couch on which diners in Roman times reclined. (The same gesture of archaeological precision reappears in *Eucharist*). The practice is not entirely innovatory, as Poussin suggested, for it was introduced into engravings in the late sixteenth century, following much discussion among humanist scholars of the Cinquecento. None the less, the monumental treatment of the motif by Poussin goes some way towards justifying his claim (in a letter to Chantelou) to have introduced something new.

In *Unction* we see the death-scene of a Roman soldier in a severely classical setting. A priest is anointing him with holy oil, and against the back wall (second series, no. 40) we see the shield with the Chi Rho, the monogram of Christ, which identifies the soldier explicitly as a *miles Christi.* Every detail is archaeologically exact here: the poses of the mourners (based on classical funerary reliefs), the bed on its platform, while the garlanded priest would seem to have been modelled on the bent old man in the famous Capitoline Meleager relief.

The setting of *Confirmation II* (no. 41) – an entirely closed building – is also a more convincingly 'early Christian' context than the Cinquecento church in the first series. The huge sarcophagi in the background suggest that the scene is in the catacombs. Perhaps the details do not exactly correspond to our modern knowledge of the catacombs, but they are in accord with the data in protoarchaeological works of the day. The corpse being laid out in the background tends to confirm the catacomb interpretation; and the juxtaposition of funerary and initiatory rites probably makes visual the theology of baptism, as a passage from death to life. In this picture one particularly notes the pains Poussin took to get the costumes right: the women correctly dressed in *stola* and long *palla,* the kneeling men in togas. Even the women's coiffures follow styles seen in Roman portrait busts.

Blunt has made a strong case for seeing the whole composition of *Ordination II* (no. 53) as based on an early Christian sarcophagus in the Borghese collection. The relief shows Christ with the Twelve Apostles,

handing a scroll to Peter. This is the iconography of the *traditio legis*: Christ the New Moses entrusting the New Law to the Prince of the Apostles. The scroll reappears in a preliminary drawing in the Louvre, but Poussin seems to have changed this to keys in the finished work, presumably to be more in accord with the Gospel allusion to the keys of heaven (Matthew xvi.19).

Another intriguing iconographic detail here is the large 'E' cut into the column on the left. This may stand for *Ecclesia,* the foundation of the Roman Church on Peter; but more probably recalls Plutarch's tract (*Moralia* v, 384f) on the mysterious 'E' at Delphi, which, he suggests, relates to the external existence of Apollo. This meaning could easily be transposed to the Christian God (the great 'I am' of Exodus iii.14), in which case – given Poussin's known familiarity with Plutarch, and his interest in comparative religion – we have here a hidden reference to the mysteries of Greek religion as a parallel to the Christian sacraments. A further allusion to pagan philosophy may be indicated by the walking and reading figures in the background trees, which suggest the theme of the philosophers' grove.

The Sacraments are also replete with liturgical details reflecting ancient usages which had long since ceased to be current in Poussin's day. In *Eucharist II* (no.54), for example, we have communion in the hand (not in the mouth), as laid down by Tertullian and St Cyril of Jerusalem. But the picture that most fully illustrates the thoroughness of Poussin's research in the patristic sources is *Confirmation*. In the first series (no.35) the Paschal candle and moonlight make it clear that this is Easter Eve, the preferred date for Christian initiation in the ancient Church. Until the sixth century, baptism and confirmation formed a single initiatory rite, performed on the same day; and one can see (second version, no.41) a large basin, big enough for semi-immersion, in the back chamber, suggesting the baptism of the confirmands has very recently taken place. Poussin is quite correct to show candidates of differing ages. Adult conversion and baptism remained common until at least the fifth century.

Not all the details of the depiction are beyond dispute: it would for instance be normative (at least since the time of Constantine in the West) to have the candidates in white clothes; the kneeling man should not have a purple stripe across the breast of his toga; and it is somewhat anomalous to find the chief officiating priest (seated) in vestments, but the other priest (binding the heads of the already chrismated with fillets) in generalized classical robes.

But, by and large, one is amazed at the care Poussin has taken, even with small liturgical details. Look, for instance, at the row of acolytes: one (kneeling, left) with the chrism, another (standing, right) with the bowl of lint, and a third carrying a basin with milk and honey. Until the time of

Gregory the Great, this last was received by the neophytes after the Paschal Mass (Poussin has telescoped things a bit here!) as a symbol of their entering into the Promised Land of the Kingdom of God.

In short, all the basic details of the Roman rite of Confirmation around c. AD 450 have been illustrated here, and put in a setting in which every aspect of architecture and costume has been conformed to classical models.

In conclusion, we have seen how in his Sacraments, and particularly in the second series, Poussin has synthesized his own conceptual vision with the best available classical and patristic learning of his day, to produce a minor revolution in iconography. The result is a remarkable blend of archaeological accuracy and expressive power, a monument to the Christian humanism of the seventeenth century.

(Nicholas Gendle)

Technical notes on the two sets of Sacraments

I. The first series*

While, because of their uniformity, the technical aspects of the second series, painted for Chantelou, are easily summarized the same is not true of the first series painted for dal Pozzo. Indeed, in contrast, the most notable feature is the variety of materials used and to a lesser degree, in the differing conservation treatment of the set over the years.

The canvas type ranges from the fine, normal weave of *Ordination* through the heavier normal weave of *Marriage* to the twill-pattern weave of the other three subjects. Even these differ from one another; that of *Confirmation* is more prominent in grain than the other two.

All the canvas textures are modified by the relative thickness of the priming layer and here too variety appears from painting to painting. *Ordination* is thinly primed with a pale red-brown layer which does not entirely fill the grain of the canvas while the heavier canvas of *Marriage* is more thickly primed with a deeper-coloured red-brown layer which almost obscures the effect of the weave. Of the twill canvases *Extreme Unction* is thickly primed with a red-brown coating which gives an almost smooth finish to an otherwise rather rough canvas, as can be ascertained from a fortunately preserved tacking edge, while *Eucharist* on a more smoothly woven cloth is primed with a deep red-brown layer which is so thin that abrasion has laid bare the canvas in some parts. The dark-brown priming of *Confirmation* on the other hand does not entirely hide the very prominently grained canvas.

These last two subjects seem to resemble most closely the paintings from the second series but in fact differ in several respects. Whereas *Extreme Unction* is more thinly painted than any of the second set, *Confirmation* is quite heavily painted with more obvious brushwork and the nearest approach to impasto of any of the paintings, although there is some abrasion in the more thinly painted background. Many of the architectural features in this painting have been accentuated by a technique of indenting with a stylus while the paint was still soft, and although this technique is apparent to a lesser extent in *Marriage* and *Eucharist* it does not appear at all in the second series.

*Excluding the Washington *Baptism*.

68

It should also be mentioned that the variety of surface and handling of the dal Pozzo Sacraments discussed above may have been emphasized by the degree of conservation techniques carried out on individual paintings. There are minor damages in each of the canvases but nothing which seriously affects the appreciation of the painting. *Confirmation* has been wax-lined and all the others are lined with an aqueous adhesive; *Extreme Unction* appears to have an older lining which is noticeably more sympathetic to the painted surface.

The varnish on the paintings is thinly applied and very little discoloured. The paintings were surface-cleaned and varnished prior to the exhibition.

2. The second series

Although the uniform appearance of the Ellesmere series is exaggerated to some extent by discoloured varnish other, more basic reasons, must be taken into account by way of explanation.

The canvas of all seven paintings is of medium-weight twill weave and the priming is a deep red-brown colour which may be deepened further in tone by a wax lining which is also common to all the paintings. The condition of the canvases is uniformly good and the wax lining has apparently been carried out to reinforce the presumably fragile support as there are no obvious structural deficiencies which might otherwise demand such treatment.

Within each painting certain colours – white, blue (where mixed with white), yellow (probably a lead-based pigment), and vermilion especially – seem over-emphasized against the dark background while other colours, probably mainly earth pigments, merge into the general tone. Some of the subordinate figures suffer particularly in this respect. This is a fairly familiar phenomenon in seventeenth-century paintings done on dark priming and can be explained by several factors of ageing; but it is probably mainly the result of the increasing translucency of the paint with age, due to the rise in the refractive index of the oil medium. As the dark ground, thinly covered with paint, often serves as the middle tones of the painting, these have now largely lost their function because of this increasing transparency and throw the more opaque colours into unnatural relief. It is ironic that the dark ground, which must have served as a unifying influence for the painter, now exerts the opposite function causing the somewhat discordant tonal values we now experience.

Apart from this result of chemical change of the paint, the condition of the seven paintings is excellent. Although one or two of the paintings (*Baptism* and *Penance*) show very little signs of craquelure, probably because of the thinness of the paint and priming, others such as *Extreme Unction* and *Confirmation* and, even more so, *Ordination* show quite pronounced

craquelure where paint is more thickly applied which leads to cupping of the paint in some areas.

There are so few signs of pentimenti (artist's alterations) that it is worth mentioning the couple of instances where they do occur; that is in the yellow robe of the priest in *Extreme Unction* and in the white robe of the seated figure at the extreme right of *Penance*.

The handling of the paint in this series is fairly smooth, with few signs of brushwork, and the modelling tends to be softened and blended, although the painting of the draperies in *Penance* is rather more complicated in design and crisper in treatment than the others.

(John Dick)

The Seven Sacraments (first series)

Commissioned by Cassiano dal Pozzo during the 1630s; the last painting in the series (*Baptism*) was completed in May 1642 when it was despatched from Paris. For the individual pictures in the series, see below.

coll: Cassiano dal Pozzo in Rome; by inheritance to Cosimo Antonio dal Pozzo, grandson of Cassiano's younger brother, Carlo Antonio, and then to Cosimo's daughter Maria Laura who married into the Boccapaduli family in Rome in 1727; bought in 1785 by James Byres, a Scottish dealer, for the Duke of Rutland of Belvoir Castle who was forming a collection on the advice of Sir Joshua Reynolds (for the negotiations see the letters of James Byres in *Historical Manuscript Commission 14th Annual Report. Appendix Part 1. The Manuscripts of his Grace the Duke of Rutland preserved at Belvoir Castle,* vol.III, 1894; see also the *Letters of Sir Joshua Reynolds,* ed. F. W. Hilles, 1929, pp.125ff, p.139, and pp.161ff); exhibited Royal Academy, London, 1787. One painting, *Penance,* was destroyed by fire at Belvoir in 1816. *Baptism* was sold and belongs to the National Gallery of Art, Washington (no.37). The other five paintings from the series remain at Belvoir Castle (nos.31–5).

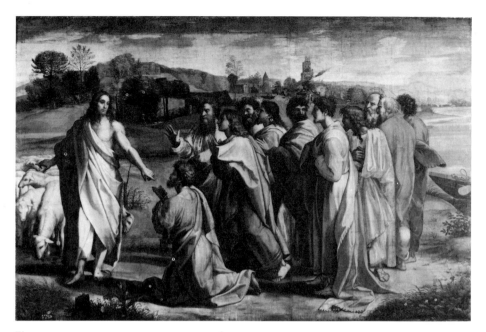

Fig.19
Victoria and Albert Museum, London

Fig.20
National Gallery, London

31

Ordination

Oil on canvas; 95·5×121cm

Christ gives the keys to St Peter. Poussin's interpretation of the subject shows the direct influence of Raphael's tapestry cartoon of the same subject (see fig.19); but whereas in Raphael's version the figures assume the stature of archetypes, expressing abstract emotions, the Apostles in Poussin's picture are still clearly individuals who convey specific and particular reactions to the actual events taking place around them. The casual grouping of the figures in Poussin's version (see fig.37), and the free exploratory handling of the draperies, are also quite different from the geometric clarity and classical stability of Raphael's prototype. In this reinterpretation of Raphaelesque history painting, Poussin may well have been influenced by the earlier example of Annibale Carracci who first made the essential transition from the monumental effects of Raphael's cartoons to the more intimate mood of small canvases such as *Christ appearing to St Peter* (fig.20), of *c.*1602, formerly in the Aldobrandini collection, Rome. The sequence in which Poussin completed the seven pictures from the first series of Sacraments is not documented. Nevertheless there are stylistic grounds for supposing that *Ordination* was one of the earliest. The frieze-like arrangement of the apostles in front of the landscape, which consists of a screen of trees, echoing the relationship of the figures, suggests a date no later than 1636–7. It is close to *Moses striking the rock* (no.28) and *St John baptizing the people* (no.30); and the possibility that it was painted before the Richelieu Bacchanals of 1635–6 (nos.18 and 24) cannot entirely be excluded.

ref: Blunt 1966, no.110

The Duke of Rutland

32

Marriage

Oil on canvas; 95·5×121cm

The marriage of the Virgin. The arrangement of the remarkably tall and slender figures, carefully balanced within a confined and enclosed symmetrical interior space, is far less informal than in *Ordination* (no.31). The draperies are also more firmly modelled. There are brilliant passages of abstract surface design, such as the subtle but geometrically conceived relationship of sandalled feet in the right foreground, which suggests the picture might have been conceived around the same time as *Extreme Unction* (no.33), where the same qualities are even more pronounced.

ref: Blunt 1966, no.111

The Duke of Rutland

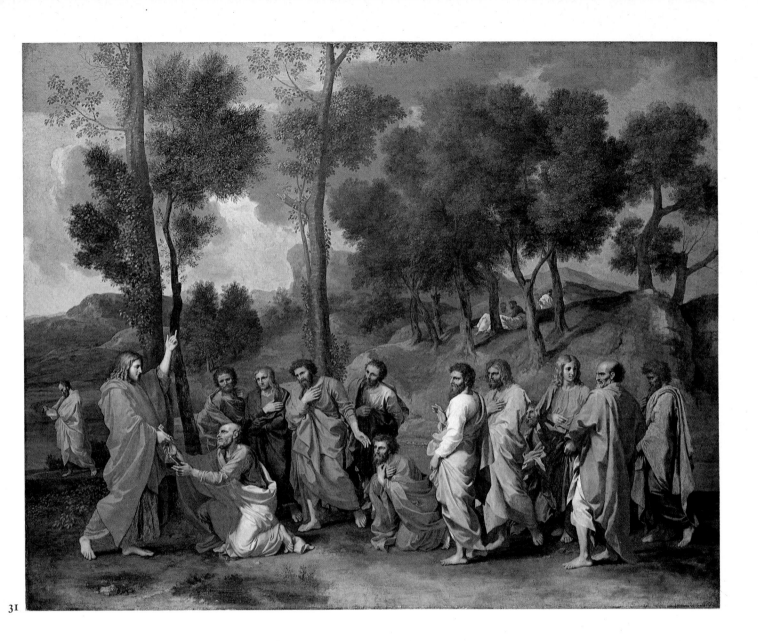

31

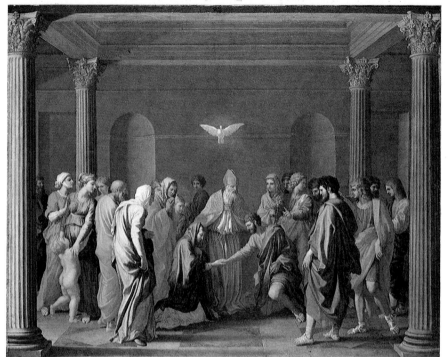

32

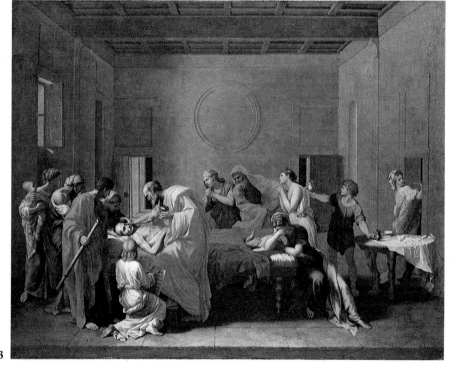

33

Extreme Unction

Oil on canvas; 95·5×121cm

The ceremony of annointing the dying man with oil is here carried out in accordance with the ritual of the Roman Church. Poussin had already painted an antique form of death-bed scene, the *Death of Germanicus* (fig.22) of 1627 (Minneapolis), which was also conceived as a relief and had been inspired by his knowledge of one of a closely related group of Roman sarcophagi representing the *Death of Meleager* (fig.21; engraving by François Perrier after the Meleager relief in the Villa Albani, Rome, from *Icones . . . Tabularum,* Paris 1645). The *Extreme Unction* is a direct development of the same concept, but here the spatial ambiguities and overlapping human forms of Poussin's earlier work are entirely eliminated. The figures are arranged in a stage-like setting, with the forward edge of the floor deliberately exposed. Here Poussin was probably influenced by Domenichino's fresco of the *Flagellation of St Andrew* (fig.6). In spite of this theatrical effect, combined with memorable anecdotal details in the treatment of certain figures, such as the maid on the extreme right (fig.47), the principal emphasis is not on direct story-telling, as in Domenichino's fresco, but on the surface design of the picture. The clearly defined contours of the figures, their eloquent and rhythmic spacing across the picture surface, and the geometric emphasis of doors, windows, and architectural recesses, together mark a major stylistic advance beyond the more informal arrangement of *Ordination* (no.31). The superb design of *Extreme Unction* does

however deprive the various figures of their individuality. As if to emphasize this, Poussin has based two of them, the priest and the kneeling acolyte (see fig.45), on Domenichino's celebrated painting of the *Communion of St Jerome* (fig.23). A study for one of the mourners on the left is sketched on a sheet of studies (no.21) made in connection with the *Triumph of Pan* of 1635–6 (no.18). *Extreme Unction* is also particularly close in technique to the *Triumph of Pan* (no.18), light in tone, firmly but dryly painted, with each colour precisely placed, and occupying a clearly defined area. Although this evidence is far from conclusive, one cannot exclude the possibility that *Extreme Unction* is contemporary with the Richelieu Bacchanals. In stylistic terms the picture develops naturally from the *Adoration of the Magi* in Dresden of 1633, and could well date from the mid-1630s.

exh: Bologna 1962, no.68

ref: Blunt 1966, no.109

The Duke of Rutland

Fig.21
François Perrier, engraving after the *Meleager* relief in the Villa Albani, Rome, from *Icones . . . tabularum,* Paris 1645

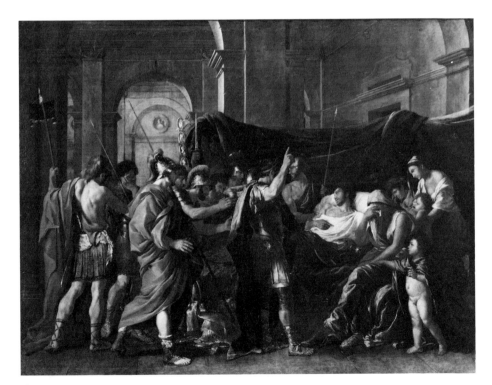

Fig.22
Minneapolis Institute of Arts

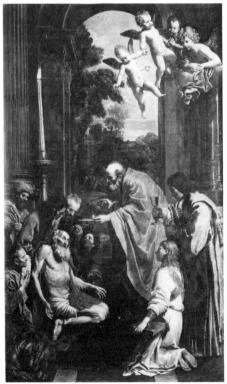

Fig.23
Vatican Gallery

75

34a

. . . in the famous Picture of *Poussin,* which represents the *Institution of the Blessed Sacrament,* you see our *Saviour* and *his twelve Disciples,* all concurring in the same action, after different manners, and in different postures, only the manners of *Judas* are distinguish'd from the rest. Here is but one indivisible point of time observ'd: but one action perform'd by so many different Persons, in one Room, and at the same Table: yet the eye cannot comprehend at once the whole Object, nor the Mind follow it so fast; 'tis consider'd at leisure, and seen by intervals. Such are the subjects of Noble Pictures: and such are only to be undertaken by *Noble Hands.*

(JOHN DRYDEN, *A Parallel betwixt Painting and Poetry,* 1695, p.xxv. Preface to English translation of C. A. DUFRESNOY's *De Arte graphica*)

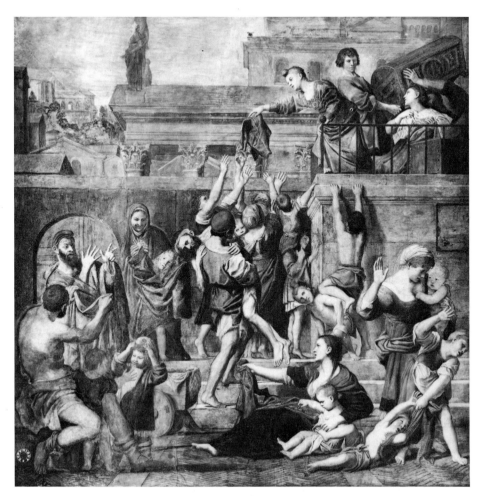

Fig. 24
San Luigi dei Francesi, Rome (see p.78)

34

Eucharist

Oil on canvas; 95·5 × 121 cm

The Last Supper, with Christ blessing the cup. In accordance with ancient Roman practice, the Apostles are shown reclining on a couch around the table. Thinly painted on a dark ground, and similar in style to *Confirmation* (no.35). The most remarkable feature of this picture is the lighting which comes from at least three different sources: the open door from which light is thrown onto the vast back wall of the room, a candle which throws extraordinarily complex abstract patterns of light and shade onto the empty spaces and austere furnishings of the foreground area (pl.34a), and a lamp above Christ's head which concentrates our attention on the symbolic ritual below. The effect of these dramatic lighting effects is to emphasize the physical isolation of the figures, who are dwarfed by their architectural surroundings. At this date, only Caravaggio had used light and shade with such symbolic and dramatic effect, as in his *Calling of St Matthew* in the church of San Luigi dei Francesi. But whereas Caravaggio's figures are remarkable for their physical naturalism, Poussin's are physically and psychologically remote, and inhabit a quite different environment, both in time and place, to that of the spectator. The Apostles lack individuality and already assume the stature of archetypes, a quality which was developed even further in the Sacraments of the second series (cf. figs.35 and 36).

ref: Blunt 1966, no.107

The Duke of Rutland

35

Confirmation

Oil on canvas; 95·5 × 121 cm

The confirmation ceremony is shown in two stages. In the foreground a priest anoints the forehead of the child with the chrism; behind him another priest binds a fillet on the forehead of a second child who has already received a chrism. A paschal candle burns on the altar, indicating that it is Easter Eve (Blunt 1967, p.189). Blunt has suggested that the architecture of the church recalls quite closely Sant' Atanasio dei Greci, which stood exactly opposite Poussin's house in Rome. The picture, painted on a dark ground, is close in style to *Eucharist* (no.34), although it is more solidly

painted, especially in the quite fluid treatment of the draperies (see further S. Rees Jones, *Burlington Magazine,* CII, 1960, pp.307ff, fig.17). At least some of the figures, including the standing child on the left, were originally laid in nude. Perspective lines drawn into the paint surface (but not into the ground) to give added emphasis to the pattern of the floor, go through the draperies, apparently up to the edges of the unclothed figures (see the X-ray on p.113). The composition divides into two sections, the priest attended by two acolytes confirming a child on the right, and on the left a much more informal group of people awaiting their turn. The right-hand group was probably inspired by Domenichino's *Communion of St Jerome* (fig.23), most particularly for the priest and the acolyte immediately behind him, and also for the sense of figures dwarfed by a towering architectural background. The stage-like setting of the overall design, the anecdotal diversions in the left-hand group (see fig.39), and even the psychological concept of an answering space between the individual figures, must all have been influenced by Domenichino's narrative frescoes, such as the cycle from the life of St Cecilia in San Luigi dei Francesi (fig.24). This picture was perhaps completed in the late 1630s.

exh: Paris 1960, no.61; Bologna 1962, no.69

ref: Blunt 1966, no.106

The Duke of Rutland

36

Confirmation

Pen and bistre wash over black chalk; 136×207mm

A study for the picture in the first series in which the arrangement of the figures is basically the same. In the latter, however, they are more spread out and the heads reduced to almost one level in order to emphasize the lateral rhythm which the figures generate in the painting.

coll: from the second volume of Poussin drawings at Windsor – see no.21

exh: Newcastle 1951/2, no.10; Paris 1960, no.166

ref: CR, I, no.85, pl.55; Blunt, *French Drawings,* no.205, pl.52

Her Majesty The Queen (Windsor 11896)

37

Baptism

Oil on canvas; 95·5×121cm

St John baptizes Christ. The picture was begun in Rome, before Poussin's departure to Paris in 1640, but was not completed until May 1642. The figures are much larger in scale than the other paintings from the series, and the landscape is more monumental, with a much greater sense of structure than in the background of *Ordination* (no.31). Yet the landscape also seems less developed in style than the *Landscape with St Matthew* in West Berlin and the *Landscape with St John the Evangelist on Patmos* in Chicago, both of which may be dated 1640 on the basis of recently discovered documents (see L. Barroero, *Bollettino d'Arte,* 1979, IV, p.69). This might suggest that at least the landscape in *Baptism* had been essentially completed before Poussin left Italy. By the artist's own account (letter to dal Pozzo of 27 March 1642) the figures of Christ and the two angels were the last to be completed. The design of this picture lacks the dramatic clarity of *Confirmation* (no.35). Poussin's tendency towards abstraction in the treatment of the figures is emphasized by the obvious quotations from Renaissance prototypes. The man putting on his stockings, repeated from the *St John baptizing the people* (no.30), is derived from Michelangelo's Cascina cartoon (also engraved by Marcantonio Raimondi; see fig.25, p.82). The man pulling off his shirt has also been taken from Michelangelo's cartoon. The two angels are inspired by Raphael's fresco *St John baptizing Christ* (fig.26, p.82).

ref: Blunt 1966, no.105

National Gallery of Art, Washington (Samuel H. Kress Collection 1946)

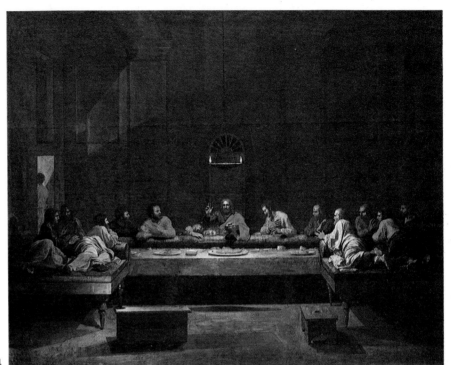

34

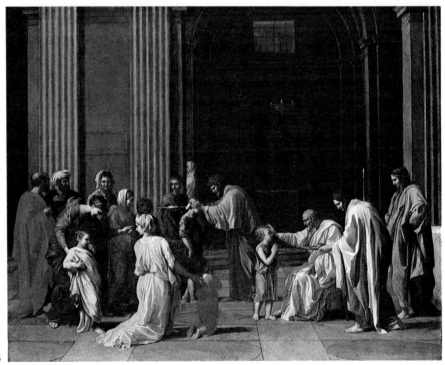

35

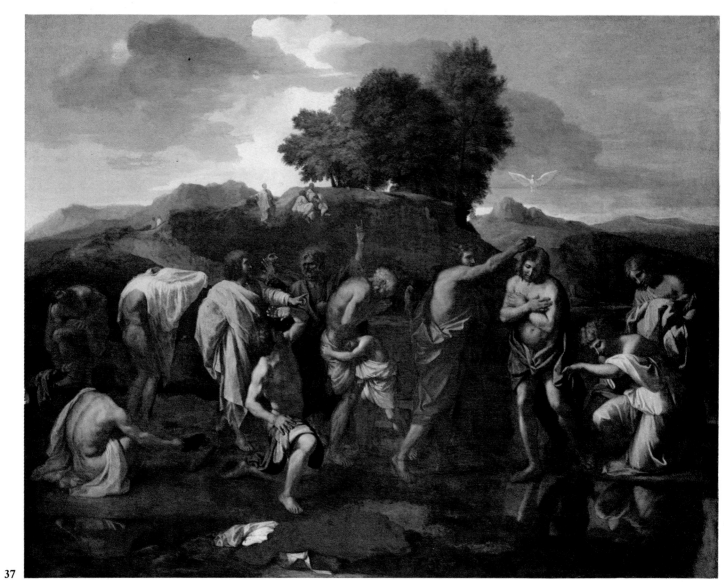

37

36

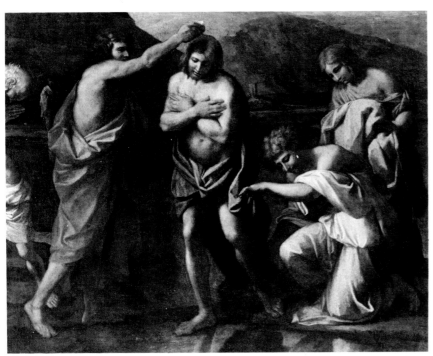

37a

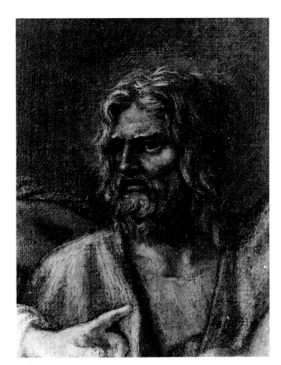

37b

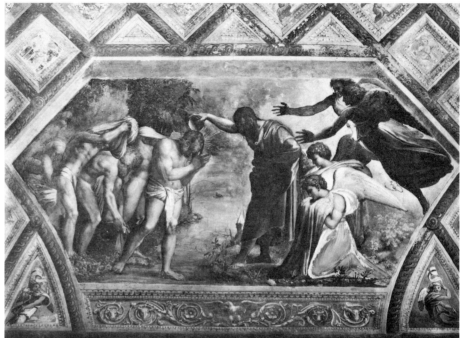

Fig.25
Marcantonio Raimondi, after Michelangelo

Fig.26
Vatican Loggias

Fig.27 (not exhibited)
Musée Condé, Chantilly

82

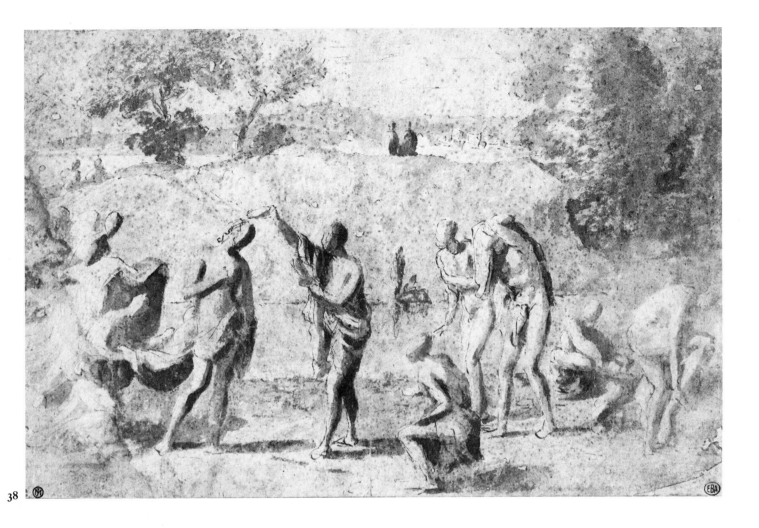

38

38

Baptism

Pen and bistre wash; 183×281mm

The arrangement of the figures in a
drawing at Chantilly (fig.27) is essentially
that in the painting. In the present sheet the
composition is reversed, with Christ on the
left and St John in the pose which Poussin
developed in the drawings for the painting
in the second series.

coll: Ph. de Chennevières; Jean Masson

exh: Paris 1960, no.168

ref: CR, 1, no.76, pl.49

Ecole des Beaux-Arts, Paris (Masson 1118)

39

Penance

Engraving by Louis de Châtillon
(1639–1734)

The original painting was destroyed by fire
at Belvoir in 1816. The Magdalen washes
Christ's feet in the house of Simon the
Pharisee. The guests recline on *triclinia* or
couches, in accordance with ancient Roman
practice. To judge from the design, with a
relatively informal and crowded grouping
of the figures, and the shallow landscape
background, with a frieze of trees on the
left, the picture might have been close in
style to *Ordination* (no.31).

ref: G. Wildenstein, *Les Graveurs de Poussin
au XVII Siècle,* 1958, p.223 and no.93;
Blunt 1966, no.108

The Trustees of the British Museum

Sacramentum Pœnitentiæ

The Seven Sacraments (second series)

Commissioned by Paul Fréart de Chantelou and painted 1644–8. The progress of the project is well documented by Poussin's correspondence with his patron in France.

coll: Fréart de Chantelou (died 1694) Paris; his nephew Roland Fréart (died 1707); the latter's nephews, the brothers Favry (M. Rambaud, *Documents du Minutier central,* Paris, II, 1971, p.798); in the collection of Jaques Meyers of Rotterdam by 1714 (P. Nougaret, *Anecdotes des Beaux-Arts,* 1776, II, p.128); bought 1716 by Duc d'Orléans; sale Bryan's Gallery, London 1798, reserved for the Duke of Bridgewater; thence by inheritance. Bridgewater House nos.63–9.

40

Extreme Unction

Oil on canvas; 117×178cm

The shield in the background indicates that this scene represents the death of a Christian soldier. It was begun by 15 April 1644 and was completed by 30 October 1644. The specific role of each of the individual protagonists is defined with much greater clarity than in the earlier version, and there is a greater range of emotional response (cf. figs.33 and 34). The surface design, the physical inter-relationship of the figures, is also much more complex. As Poussin informed Chantelou (25 April 1644): 'The . . . picture will contain figures, of men, of women, of children young and old, some overcome with weeping, and others praying to God for the dying man.' Yet anecdotal details, not strictly relevant to the central theme, are rigorously suppressed. For instance the lively serving maid on the extreme right of the Belvoir picture is replaced here by a contemplative figure of much greater dignity (cf. figs.47 and 48). The scene is illuminated both by natural light from the open door on the left, which reflects on the shield in the centre of the picture, and also by candlelight which creates a strong chiaroscuro (carefully calculated in a superb preparatory drawing in the Louvre), and allows the artist to lay particular stress on the reactions of the principal mourners.

exh: Newcastle 1951/2, no.1; Paris 1960, no.69

ref: Blunt 1966, no.116

Duke of Sutherland (on loan to the National Gallery of Scotland)

41

Confirmation

Oil on canvas; 117×178cm

Begun by 30 April 1645 and completed by 10 December 1645. The ceremony is shown as taking place in the Roman Catacombs. The design is far more unified than in the earlier Belvoir picture, with the procession of figures from right to left towards the seated priest nicely counter-balanced by a parallel movement in the opposite direction behind them. Genre-like human touches in the Belvoir version have here been suppressed (cf. figs.39 and 40). The slender standing female on the right (fig.43) has the air of a figure from an antique fresco such as the Aldobrandini *Wedding* which had been discovered in 1606 (fig.28). The draperies of the priest and acolyte are modelled with a firmness and strength which suggest the permanence of antique sculpture (fig.46). There is a strong source of light from the left (its origin is not shown) which illuminates and clarifies the facial expressions of the principal figures. Poussin devoted very considerable attention to each of these individuals. As he informed Chantelou on 20 August 1645: '. . . if I am able to finish your picture of Confirmation and send it to you by the end of the year, I shall think I have done well. It contains twenty four complete figures, to say nothing of the architectural background, and is such that no less than five or six months will be needed to finish it properly: moreover, Sir, when you come to consider it, these are not things that one may do a-whistling, like your painters of Paris, who amuse themselves by dispatching a picture in twenty four hours. If I complete a head in a day, and give it its proper effects, I feel I have done a good day's work.'

exh: Newcastle 1951/2, no.2; Paris 1960, no.70

ref: Blunt 1966, no.113

Duke of Sutherland (on loan to the National Gallery of Scotland)

Fig.28
The Vatican, Rome

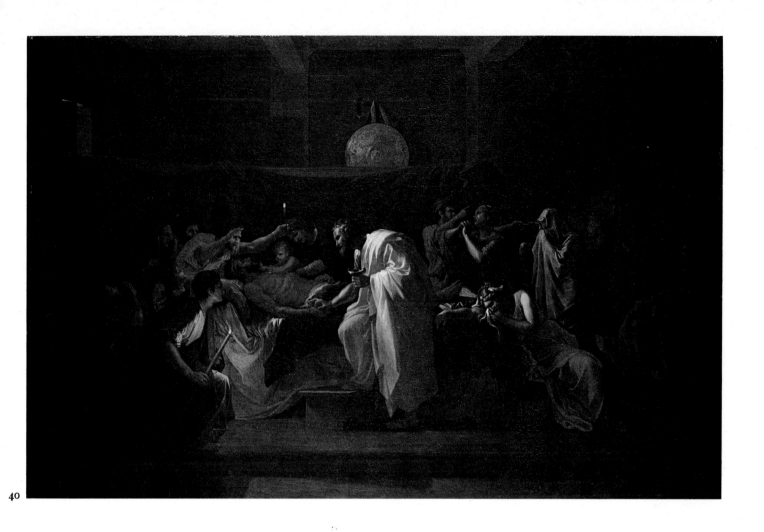

40

On peut dire que, malgré sa partialité pour l'Italie, il est le moins italien de tous les peintres.

(DELACROIX, *Essai sur Poussin*, 1853)

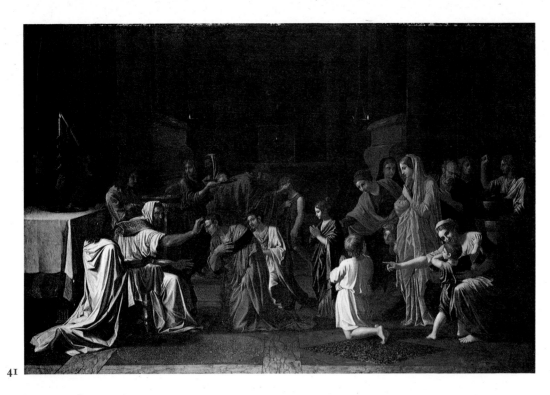

41

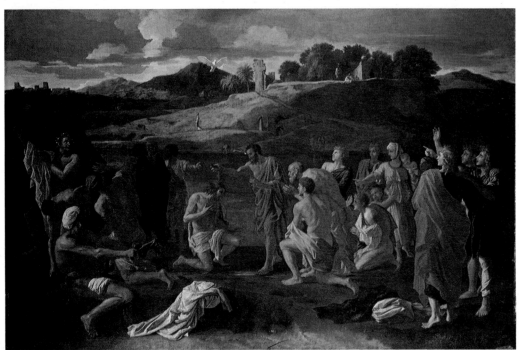

47

42

Confirmation

Pen and bistre wash; 181×257mm

This and the following four drawings relate to the Sutherland version (no.41). The present one must be among the earliest studies for the picture since both the setting and the size of figures in relation to it recall the first version. This drawing which is remarkable for the beauty of the washes may have been drawn before Poussin decided on the symmetrical arrangement of the pictures in the second series. The (unconnected) female head at the top is drawn on the back of the sheet.

coll: from the second volume of Poussin drawings at Windsor – see no.21

exh: Newcastle 1951/2, no.11; Paris 1960, no.205

ref: CR, 1, no.86, pl.56; Blunt, *French Drawings,* no.215, pl.59; Thompson, p.26

Her Majesty The Queen (Windsor 11897)

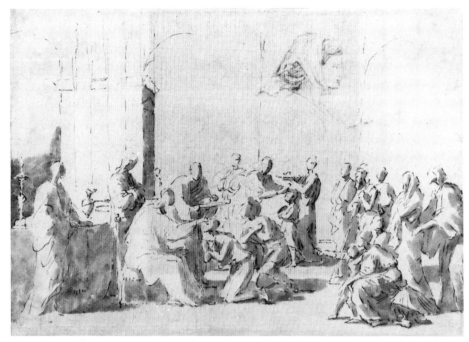

42

43

Confirmation

Pen and bistre wash over indications in black chalk; 122×245mm

coll: P.-J. Marriette; Sir Thomas Lawrence; His de la Salle

exh: Paris 1960, no.206

ref: CR, 1, no.87, pl.57; Blunt, *Drawings,* pl.127

Cabinet des Dessins, Musée du Louvre, Paris (M.I.995)

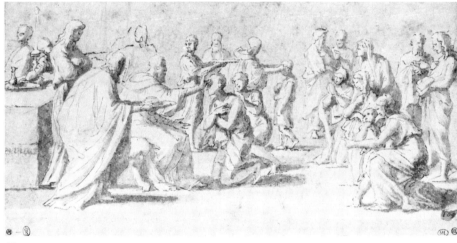

43

44

Confirmation

Pen and bistre wash; 130×253mm

The arrangement of the figures is very similar to that in the preceding study. Poussin's concern with the lighting of the scene is more evident in this study, a marvellous drawing, in which something of the mystery of the event is conveyed through the dramatic washes.

coll: P. Fréart de Chantelou; Sir Thomas Lawrence; His de la Salle

exh: Paris 1960, no.207

ref: CR, I, no.88, pl.57; Blunt, *Drawings,* pl.128

Cabinet des Dessins, Musée du Louvre, Paris (M.I.994)

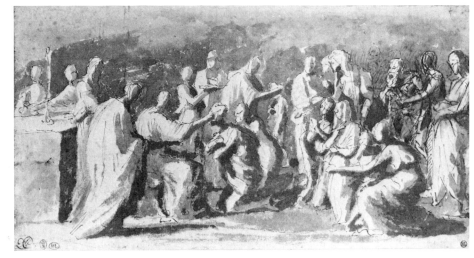

44

45

Confirmation

Pen and bistre wash over indications in black chalk; 125×253mm

This is a development of the foreground sequence of figures in which the deacon on the left is now shown kneeling. The awkward gap in the composition between the group on the right and those being confirmed in the centre, so marked a feature of the first drawing (no.42) and persisting in the following ones, is solved in this study by the introduction of the kneeling boy in the foreground and other changes which link the two halves of the design.

coll: P. Fréart de Chantelou; Sir Thomas Lawrence; His de la Salle

exh: Paris 1960, no.208

ref: CR, I, no.89, pl.58; and v, p.89; Blunt, *Drawings,* pl.129; Thompson, p.26

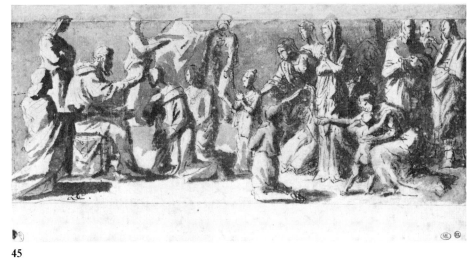

45

Cabinet des Dessins, Musée du Louvre, Paris (M.I.996)

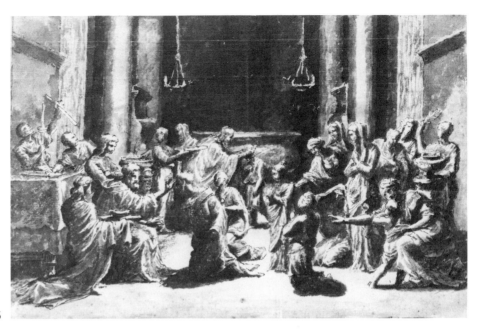

46

46

Confirmation

Pen and bistre wash; lightly squared for transfer. 185×286mm

The figures are arranged as in the painting but are lit from above, and not from the side as in the latter. They 'cease to be participants in a processional movement, they become static and isolated, cut off from each other by the shadows that encircle them like islands' (Thompson, p.26).

coll: from Cardinal Massimi's album of Poussin drawings at Windsor – see no.16

exh: Newcastle 1951/2, no.12; Paris 1960, no.209

exh: CR, I, no.A20, pl.72; and V, p.89; Blunt, *French Drawings,* no.261, pl.69; Blunt, *Drawings,* pl.130

Her Majesty The Queen (Windsor 11898)

47

Baptism (see p.88)

Oil on canvas; 117×178cm

St John baptizes Christ. First mentioned in a letter of 4 February 1646. Completed by 18 November 1646. The design is more orderly and schematic than in the *Baptism* from the first series (no.37). The reactions of the spectators are more clearly defined, those on the right expressing wonder and astonishment at the appearance of the dove, the men on the left, in the background, appearing puzzled and sceptical. The man in the foreground putting on his stockings, derived from Michelangelo, has been taken over from the earlier version, but is here more closely integrated with the figures surrounding him, who are also dressing after their baptism. As pure design this is one of the most impressive passages in any of the Sacraments, and yet the gestures of the figures still invariably lead the spectator's eye to the principal areas of dramatic interest. The contemplative mood of the picture is reinforced by the evocation of an antique world in the landscape background (fig.50).

exh: Newcastle 1951/2, no.3; Paris 1960, no.71

ref: Blunt 1966, no.112

Duke of Sutherland (on loan to the National Gallery of Scotland)

48

Baptism

Pen and bistre wash; 156×255mm

The early stages in the planning of the second *Baptism* may be observed in drawings at Leningrad (fig.29) and in the Uffizi, Florence (fig.30). In these the principal group, roughly sketched on a sheet at Dijon (fig.31), is centrally placed. The composition is developed in the present drawing in which Christ is shown kneeling. The right-hand side of the design is assuming its final form. By moving the old man and his companions from the left Poussin made a clear separation between those awaiting baptism and those who had received it. The group on the left, the subject of a separate study now in the Pierpont Morgan Library, New York (fig.32), will require modification. The man pulling on his stocking still faces to left.

coll: Thomas Dimsdale; Sir Thomas Lawrence; His de la Salle

exh: Paris 1960, no.197

ref: CR, I, no.81, pl.52; Blunt, *Drawings,* pl.123

Cabinet des Dessins, Musée du Louvre, Paris (M.I.987)

49

Baptism

Pen and bistre wash; 68×161mm

A study for the figures on the right of the composition, grouped much as they appear in the previous drawing.

coll: P. Fréart de Chantelou; Sir Thomas Lawrence; His de la Salle

exh: Paris 1960, no.196

ref: CR, I, no.80, pl.53

Cabinet des Dessins, Musée du Louvre, Paris (M.I.990)

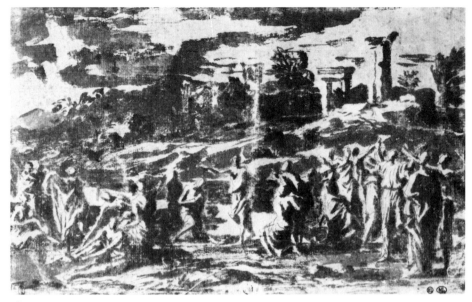

48

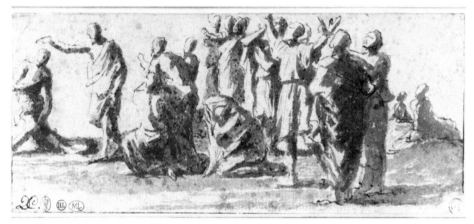

49

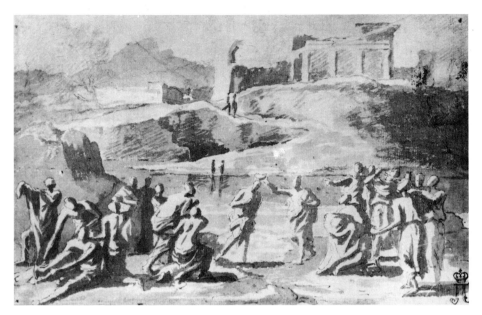

Fig.29 (not exhibited)
The Hermitage, Leningrad

Fig.31 (not exhibited)
Musée des Beaux-Arts, Dijon

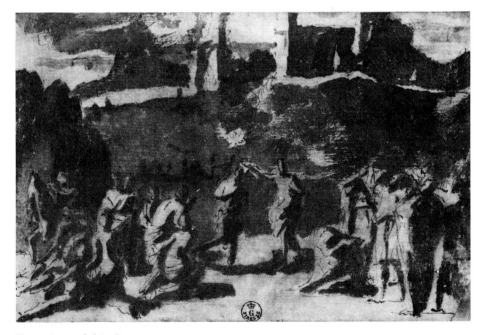

Fig.30 (not exhibited)
The Uffizi, Florence

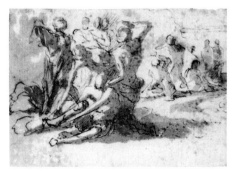

Fig.32 (not exhibited)
Pierpont Morgan Library, New York

50

Baptism

Pen and bistre wash; 86×126mm

An alternative arrangement of the figures on the right into which Poussin has fitted the standing woman with children. In the compositional drawing (no.48) they appear on the extreme left. The old man and his companions in the previous drawing are here substituted for two kneeling women encouraging a boy to go forward.

coll: Marquis de Lagoy; His de la Salle

exh: Paris 1960, no.198

ref: CR, 1, no.82, pl.53

Cabinet des Dessins, Musée du Louvre, Paris (M.I.989)

51

Baptism

Pen and bistre wash over black chalk; 164×253mm

A majestic drawing of extraordinary power and subtlety in which the figures, like ancient megaliths, are arranged almost as they are in the painting. Here they are much larger in relation to their surroundings than they appear in the first compositional study (no.48). Poussin was to change the landscape still further.

coll: P. Fréart de Chantelou; Sir Thomas Lawrence; His de la Salle

exh: Paris 1960, no.199; Bologna 1962, no.191

ref: CR, 1, no.83, pl.54; Blunt, *Drawings,* pl.124

Cabinet des Dessins, Musée du Louvre, Paris (M.I.988)

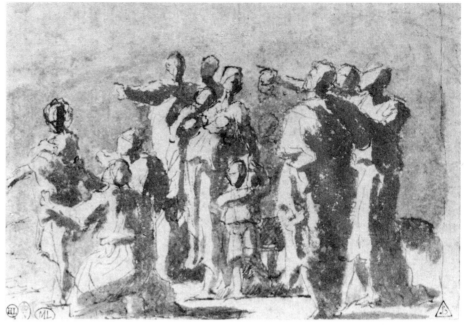

50

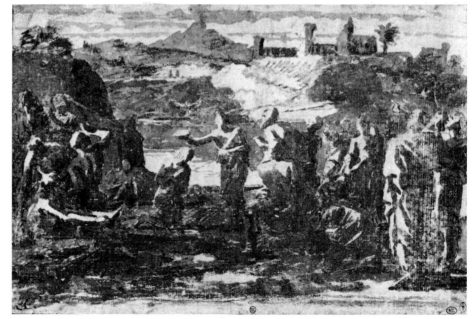

51

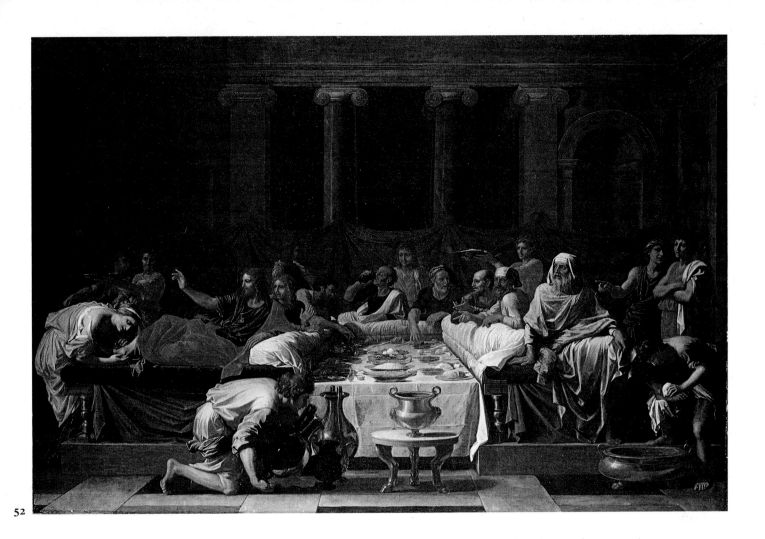

52

52a

52b

52

Penance

Oil on canvas; 117×178cm

The feast in the house of Simon the Pharisee, with the Magdalen weeping over Christ's feet. The guests recline on Roman *triclinia*. On 30 May 1644 Poussin informed Chantelou that he intended to begin this picture, but it was then postponed until 1646. In a preparatory drawing (now in Montpellier) the figures are conceived as nude forms, without facial expressions and with a complete absence of any extraneous detail. This formal approach is carried over into the final picture, above all in the magnificent self-absorbed figure in the foreground, pouring wine (pl. 52a). The design of the picture is totally symmetrical, yet by means of the lighting, as well as through the emphatic gesture of Christ, the attention is focused on the extreme left, on the figure and, above all, on the facial expression of the Magdalen (pl. 52b), the very archetype of sorrow and repentance.

exh: Newcastle 1951/2, no.4; Paris 1960, no.72

ref: Blunt 1966, no.115

Duke of Sutherland (on loan to the National Gallery of Scotland)

53

Ordination

Oil on canvas; 117×178cm

Christ gives the keys to St Peter. Begun by 3 June 1647 and despatched to Chantelou on 19 August 1647. The tower, bearing the initial E, has been superimposed over the landscape background which is clearly visible underneath. An alteration of this magnitude is unusual in Poussin's mature classical work. By placing Christ in the centre, Poussin gives the design a symmetry and dramatic focus lacking in the earlier Belvoir picture. This enables him to place much greater stress on the variety of response and gesture among the individual figures, without in any way disrupting the picture's essential unity (cf. figs. 37 and 38).

exh: Newcastle 1951/2, no.5; Paris 1960, no.73

ref: Blunt 1966, no.117

Duke of Sutherland (on loan to the National Gallery of Scotland)

54

Eucharist

Oil on canvas; 117×178cm

The Last Supper. Christ breaks bread and places it in the hands of the eleven faithful Apostles. Judas, excluded from the central group and isolated in shadow, is shown leaving the room on the left. This idea is clearly a development from the design of the earlier Belvoir version, where all twelve Apostles are seated, and an attendant is shown leaving in the background. The picture was begun by 1 September 1647 and completed by 3 November 1647. The overhead lighting, the only source of illumination in the darkened interior, dramatically and symbolically unites the reclining Apostles into a single and coherent expressive group concentrated on the figure of Christ; the architectural surroundings and the furnishings are obscured by strong shadow, adding to the claustrophobic effect. The individual Apostles are studied at much closer range than in the Belvoir version, and the tendency towards abstraction in their characterization, already noted in the earlier picture, is here even more developed, and is strongly emphasized by the elaborate sculptural quality of the draperies (cf. figs. 35 and 36).

exh: Newcastle 1951/2, no.6; Paris 1960, no.74

ref: Blunt 1966, no.114

Duke of Sutherland (on loan to the National Gallery of Scotland)

53

54

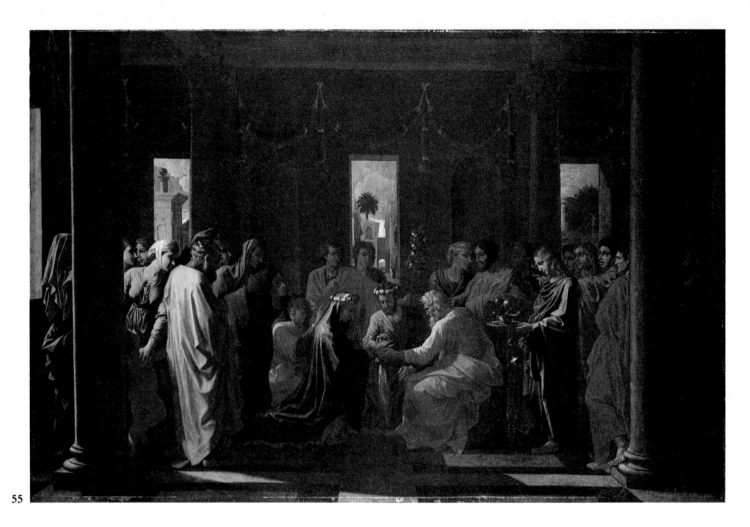

55

55

Marriage

Oil on canvas; 117×178cm

The marriage of the Virgin. Begun by 24
November 1647 and completed by 23
March 1648. Poussin originally conceived
the design without the glimpses of
landscape background, (cf. a drawing in the
Louvre, Paris), and presumably introduced
them to add an air of festivity. Chantelou
had already made it known that he regarded
the Belvoir *Marriage,* with its symmetrical
design and austere background, as the least
successful of the earlier series of
Sacraments. In this picture Poussin
successfully enlivened an essentially
undramatic subject with isolated passages
of outstanding abstract beauty, most
notably the mysteriously veiled female on
the extreme left (pl. 55a, p. 119), a figure
which was particularly admired by Bernini
when he visited Chantelou's collection in
Paris (for an account of this visit see p. 119).

exh: Newcastle 1951/2, no.7; Paris 1960,
no.75

ref: Blunt 1966, no. 118

Duke of Sutherland (on loan to the
National Gallery of Scotland)

The two sets of Sacraments compared

In this section a number of details from pictures in each set are reproduced side by side both to illustrate their individual qualities and to show, as far as such juxtapositions will allow, how they differ. It is essentially a visual demonstration. The differences in format are stressed in *A,* the more complex and compact grouping of figures in pictures of the second set in *B–D*. The greater seriousness of approach which permeates the Chantelou pictures is reflected in the choice of a more heroic, more overtly classical, type of figure, *F* and *G*, and resulted in the elimination of the picturesque and anecdotal, *E* and *H*. This new gravity was attained at the cost of spontaneity and lightness of touch and extended to the landscape, *I,* and choice of architecture, *J* – e.g. the Doric in place of the more ornate Corinthian.

First Series Second Series

A

B Fig. 33 *Extreme Unction I*

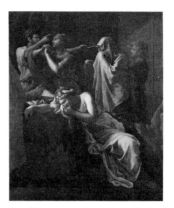

B Fig. 34 *Extreme Unction II*

C Fig. 35 *Eucharist I*

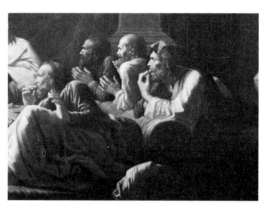

C Fig. 36 *Eucharist II*

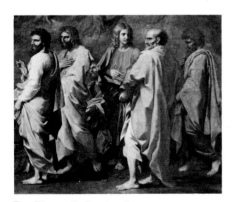

D Fig. 37 *Ordination I*

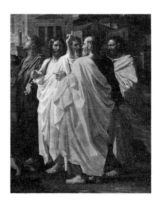

D Fig. 38 *Ordination II*

First Series

Second Series

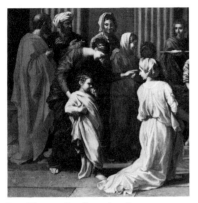

E Fig.39 *Confirmation I*

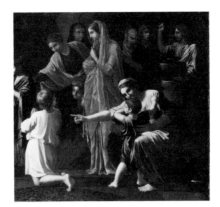

E Fig.40 *Confirmation II*

F Fig.41
Confirmation I

F Fig.42 *Extreme Unction I*

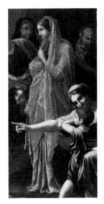

F Fig.43
Confirmation II

F Fig.44

G Fig.45 *Extreme Unction I*

G Fig.46 *Confirmation II*

First Series

Second Series

H Fig.47 *Extreme Unction I*

H Fig.48 *Extreme Unction II*

I Fig.49 *Ordination I*

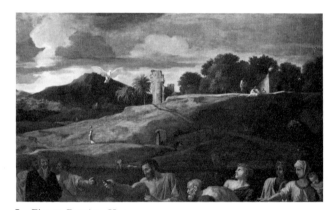

I Fig.50 *Baptism II*

J Fig.51 *Marriage I*

J Fig.52 *Penance II*

The drawings of Poussin

First impressions of Poussin as a draughtsman, especially for those who spend little time looking at drawings, are likely to be unfavourable. His drawings, unlike those by Watteau for example, are not beguiling. They lack the beauty of line so immediately attractive in those of Raphael, Ingres, and Degas and they may even repel those who judge drawings solely by this criterion. Poussin's line, although always forceful and full of meaning, even in his later years when an ailment made his hand shake, makes no concession to prettiness and is frequently rather coarse. But Poussin's drawings offer rewards of another kind and it will become apparent to those who study them carefully that his best are among the greatest drawings of the seventeenth century.

Our view of an artist as a draughtsman depends so much on survival and the accidents of collecting. That no drawings can certainly be attributed to Caravaggio does not prove that Caravaggio never drew. Likewise any assessment of Poussin's drawings must take into account the chilling fact that so many, particularly certain categories of drawings, have been lost. For example, we know that Poussin drew from the life in Domenichino's studio and that he continued this practice with Sacchi after 1631, when Domenichino went to Naples. But no life studies survive, a fact which not only distorts any assessment of Poussin but creates a gap in our knowledge of his methods of working, particularly in the matter of how he transferred his ideas to the canvas before he started to paint.

From what has survived we may safely assume that Poussin's attitude to drawing was essentially practical and that he regarded it as a means to an end. He frequently drew on sheets of paper which he had already used (see no.22), sometimes many years before. For example, the drawing on the back of no.21 is for a picture painted 15 years later than *The Triumph of Pan* to which the studies on the exhibited side of the sheet relate. Poussin drew mostly with a particular purpose in mind and rarely it would appear with the aim of producing finished works of art in their own right. In this respect the self-portrait (no.56) is unusual, and is doubly rare in that it is drawn in red chalk, a medium little used by Poussin. We know from the account of his biographer, Félibien, that he carried a notebook about with him in

which he recorded things or people that interested him, a fragment of classical sculpture or the stance or posture of some passer-by. Thus would Poussin build up a repertory of human gesture to which he would later refer, and we may confidently assume that the attitudes of many of the most memorable figures in his paintings would have been found in embryo in these jottings, waiting to be refined and given definition before being translated into painted form.

Poussin's close observation of the world around him of which Félibien writes, extended in a more formal way to his interest in landscape, which he certainly drew on the spot. The German painter, Joachim von Sandrart, who was in Rome between 1629 and 1634, mentions the occasion when he, Claude, and Poussin rode to Tivoli in order to draw from nature. One of Poussin's earliest surviving landscape drawings, *St Mary of Egypt and St Zosimus* (no. 59), is included in the exhibition. Although one must admit the possibility that it may have been drawn in the studio it would be hard to deny that the effects of sunlight among the trees so marvellously conveyed here had not been inspired by direct contact with nature. Likewise the *View of the Aventine* (no. 60) with the trees observed under a strong midday sun which forms halos around them: this must surely have been drawn on the spot. It was from such a drawing and the experience of studying nature at first hand, of which this and other drawings are proof, that Poussin must have derived inspiration when painting, for example, the serene landscape in the *Baptism* from the second series of Sacraments (no. 47).

Only a fraction of Poussin's landscape drawings have come down to us and none of the notebooks mentioned above now exist. By far the greatest number of drawings surviving today were done in preparation for paintings and of these the compositional studies, of which there is a fair selection in the exhibition, are the most numerous. What, one might ask, was Poussin attempting to do in these drawings, and what was their purpose? Essentially they are a record of his search for the composition that would express in the most effective and dramatic way possible the subject which he had chosen to illustrate. The medium most often used was pen and bistre ink, sometimes brush and bistre wash only. In these drawings the sketchiest of outlines suffice, limbs are barely indicated and heads are roughly drawn ovals. The mannequin-like appearance of the figures in many of his drawings (for example those which relate to *Baptism*) may be explained by the fact that Poussin used a model stage with wax figures as an aid to composition (no. 62).

He must have adopted this practice fairly early in his Italian career because Sandrart gives considerable prominence to it in his biography of the artist. It was a laborious process, but Poussin was a skilled modeller as his wax copy of the Vatican *Cleopatra* (which he is said to have given to Chantelou and is now in the Louvre) testifies. It is very unlikely that Poussin used his

stage for a composition that included many figures. It would have made matters too complicated, but the drawings for the Sacraments certainly suggest that he had recourse to the model when planning them. Apart from helping the artist to establish the correct disposition of the figures which he would do by remodelling them and moving them around, the model was useful to Poussin in allowing him to experiment with the lighting of the scene, which was his other chief preoccupation in these compositional studies. The drawings for *Baptism* (fig. 30) and *Confirmation* (no. 44), for example, are essentially exercises in lighting. The outline of the figures is of the most rudimentary kind with limbs indicated by a series of squiggles. But Poussin's concern here was not with anatomy but with the effect of light on the forms within the design, and the pattern of shadow created by it.

I have already discussed the character of Poussin's line. Its forceful rudimentary quality may be seen in the earliest of the drawings to have survived, namely those he produced for the poet Marino in Paris, of which one is shown here (no. 58). It is equally apparent in the studies for the Bacchanals, even in a drawing with a relatively high degree of finish (no. 23). It is however the quality of the washes that make Poussin's drawings memorable, and imparts to them their particular vividness and beauty. Within a tonal range of the greatest subtlety Poussin fixed the lighting of the composition with complete accuracy. But in his finest drawings, for example those for *Baptism* (nos. 48 and 51), and the study after Trajan's Column (no. 61) he achieved something more: a feeling of grandeur and solidity, an intimation of that higher order which he realized so completely in his pictures.

The essential quality of these drawings is one of exploration and experiment, of searching for solutions that find resolution in the paintings. The freedom of handling in the *Baptism* studies is remarkable and contrasts absolutely with the restraint and detachment of the painting. But it is one of the mysteries of Poussin's genius how he brought about the transformation. How was the fire and spirit of the original idea tamed and brought under control, and through what stages did it pass to achieve its final metamorphosis? It is here that the gaps in our knowledge of Poussin's methods of working are most apparent. No detailed studies, for example of hands and arms, have survived and we are not helped by the fact that Poussin did not run a studio like his great baroque contemporaries in Rome did. Only when he worked on the decorations of the Long Gallery in the Louvre (1641–2) did Poussin employ assistants. Otherwise he worked on his own. That he used, certainly at one stage of his career, large-scale finished drawings, which were squared up so that the design could be transferred to the canvas, is suggested by the precious fragment in the British Museum (no. 17) which relates to the National Gallery's painting. The small study for *Confirmation* (no. 46) is also squared, from which one

assumes that the design was transferred at some stage in preparation. At one point Poussin must have referred to those life studies which are now lost to us, but the mystery of the process still remains.

(HM)

I can fancy, that even Poussin, by abhorring that affectation and that want of simplicity, which he observed in his countrymen, has, in certain particulars, fallen into the contrary extreme, so far as to approach to a kind of affectation, – to what, in writing, would be called pedantry.

(REYNOLDS, *Discourses*, 1778)

56

Self-portrait

Red chalk; 375×250mm

The inscription below the drawing, although not contemporary with it, is certainly of the 17th century. It states that the portrait was drawn by the artist in front of a mirror about 1630 when he was recovering from a serious illness, and that he gave it to Cardinal Massimi, a close friend in later years. The portrait, of superb quality, is of unusual directness and candour. It is one of Poussin's rare surviving drawings in red chalk.

coll: Cardinal Massimi; F. M. N. Gabburri

ref: CR, v, no.379, pl.284; Blunt, *Drawings,* p.89, and p.195, n.20; pl.102

The Trustees of the British Museum (1901–4–17–2)

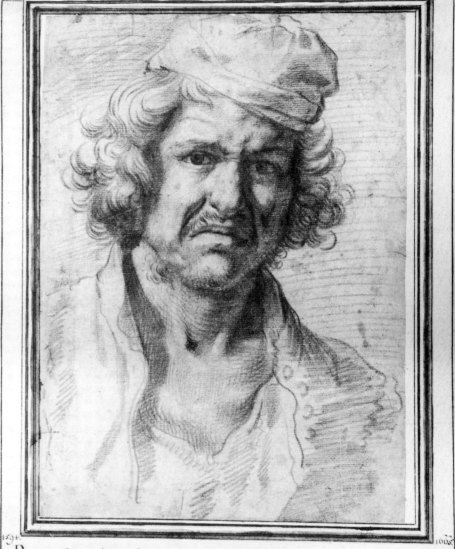

Ritratto Originale simigliantissimo di Mons.^r Niccolò POSSINO fatto nello specchio di propria mano circa l'anno 1630. nella convalescenza della sua grave malattia, e lo donò al Cardinale de Massimi allora che andava da lui ad imparare il Disegno. Notisi che và in stampa nella sua vita il Ritratto ch'ei dipinse per il Sig. Chatelou l'anno 1630. quando non aveva che anni 56. Fù buon Geometra, e prospettivo, e studioso d'Istorie. A Niccolò Possino è obbligata l'Italia, e massime la Scuola Romana d'averci fatto vedere praticato lo stile di Raffaello, ènell'antico da lui compreso nel suo fondo sostanziale imbevuto ne i suoi primi anni, poiche nacque nobile nel Contado di Soison di Piccardia in Andelò l'anno 1594. Andò à Parigi, dove dal Matematico Regio gl'erano imprestate le stampe di Raffaello, e di Giulio Romano, sulle quali indefessamente, e di tutto suo genio s'affaticò sù quello stile di disegnare ad imitazione, è di colorire à proprio talento. Futrattenuto à Parigi per alcuni quadri ordinatisi l'anno 1628. per la Canonizzazione di S. Ignazio, e S. Francesco Xaverio. Nell'Ospedale studiò d'Anatomia in Roma venuto quà nel 1624. per il Naturale all'Accademia del Disegno.

56

The Death of the Virgin

Pen and brown ink and watercolour;
395×310mm

This has been identified as Poussin's
finished sketch for a painting (now lost)
which was commissioned for a chapel in
the cathedral of Notre-Dame by the
Archbishop of Paris, in 1623. The use of
watercolour, unique in Poussin, as well as
the types of the figures, are proof of
Flemish influence with which Poussin
would have come in contact during his time
in Paris.

ref: CR, v, no.405, pl.299; Blunt, *Drawings,*
pp.27 and 113; pl.8

Private collection

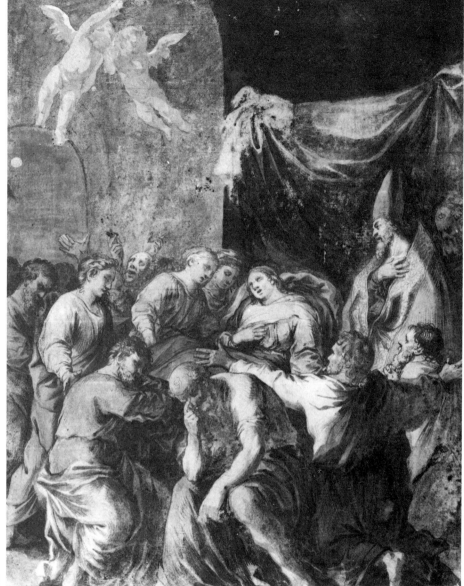

57

58

The birth of Adonis

Pen and brown ink and grey wash;
183×325mm

The naiads receive Adonis born from the
trunk of a tree into which his mother
Myrrha has been transformed. This is one
of a group of drawings which Poussin
made for the Italian poet, Giovanni Battista
Marino, during the time he was in Paris
(1615–23). Most of these have been
identified as illustrations to Ovid's
Metamorphoses and are thus the earliest
mythological subjects by Poussin to have
survived. The present drawing is
specifically mentioned by Bellori (p.410),
Poussin's biographer.

coll: G. B. Marino, on whose death in 1625
this and the other drawings mentioned
above were given to one of his Roman
friends, possibly Cassiano dal Pozzo. They
later formed part of Cardinal Massimi's
album of Poussin drawings – see no.16

exh: Paris 1960, no.120

ref: Blunt, *French Drawings,* no.154, pl.22;
CR, III, no.154, pl.130; R. V. Simon, *Art
Bulletin,* LVIII, 1978, p.57

Her Majesty The Queen (Windsor 11933)

59

St Mary of Egypt receiving the Sacrament from St Zosimus by the River Jordan

Pen and bistre wash; 225×310mm

The effect of strong sunlight among trees,
as well as the shape and structure of the
trees themselves, are conveyed in masterly
fashion by Poussin in this drawing which is
generally dated *c.* 1635.

coll: from Cardinal Massimi's album of
Poussin drawings – see no.16

exh: Paris 1960, no.152; Bologna 1962,
no.183

ref: Blunt, *French Drawings,* no.195, pl.43;
CR, IV, no.275, pl.215; Blunt, *Drawings,*
p.122, pl.53

Her Majesty The Queen (Windsor 11925)

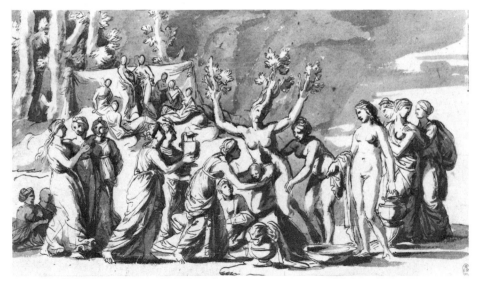

58

59

60

View of the Aventine, Rome

Bistre wash over indications in black chalk;
133×310mm

It is one of the rare drawings by Poussin of
an actual view (identified by Blunt) and one
of the few landscape drawings whose
attribution to Poussin is not in doubt. The
brilliance of execution is matched by its
state of preservation. It has been associated
by Blunt with the backgrounds in the
Chantelou *Baptism* (no.47) and *Ordination*
(no.53), and has been dated *c.* 1642.

coll: Emilio Santarelli

ref: CR, IV, no.277, pl.216; Blunt, *Drawings,*
pl.85

exh: Florence, Uffizi, *Mostra di disegni
francesi da Callot a Ingres,* 1968, no.13, fig.14
(with refs to previous exhibitions)

Gabinetto Disegni e Stampe degli Uffizi,
Florence (8101 s)

60

61

A group of soldiers

Brush and bistre wash over black chalk;
265×400mm

An illustration of two scenes on the
Column of Trajan which may have been
drawn from a cast. Dated *c.* 1626 by
Friedlaender, but assigned to the 1640s by
Blunt.

exh: London, Wildenstein's, *Artists in 17th
Century Rome,* 1955, no.60, repr.

ref: Friedlaender, p.17, fig.3; *CR,* V, no.303,
pl.245

Private collection

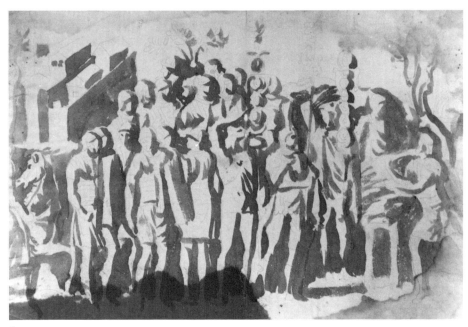

61

Model stage with figures

This is a reconstruction, following the descriptions of Poussin's contemporaries, of the model stage which he used when working out a composition involving a number of figures. His biographers tell us that he would first make sketches of the design on paper and, based on these, would then construct figures in the nude about 4½ inches high which would be set out on a board marked out in squares. This board was put in a box, open at one side and with small windows piercing the other three sides to allow the artist to experiment with the lighting of the scene. The figures would be moved about and remodelled in various attitudes. Drawings would record the effect of light and shade and the relationship of the figures to their background. Poussin would then study the figures clothed, having modelled them on a larger scale and draped them in fine linen. The making of wax models as an aid to composition was practised by artists of the 16th century (e.g. Tintoretto, Barocci, etc.). It was a laborious method however and it is proof of the great care with which Poussin planned his pictures that he employed it.

The composition which has been used to demonstrate Poussin's method is that of *Baptism*. The figures in the model are arranged according to the Paris drawing (no.38), which shows the design in the stage of transition between the picture in the first series and that in the second.

ref: Blunt 1967, pp.242–7 (with references to contemporary accounts by Bellori, Le Blond de la Tour, and Sandrart)

Lent by the Department of Fine Art, The University, Newcastle upon Tyne

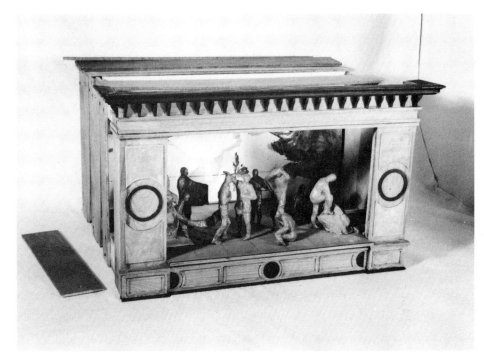

62

A selection of Poussin X-rays

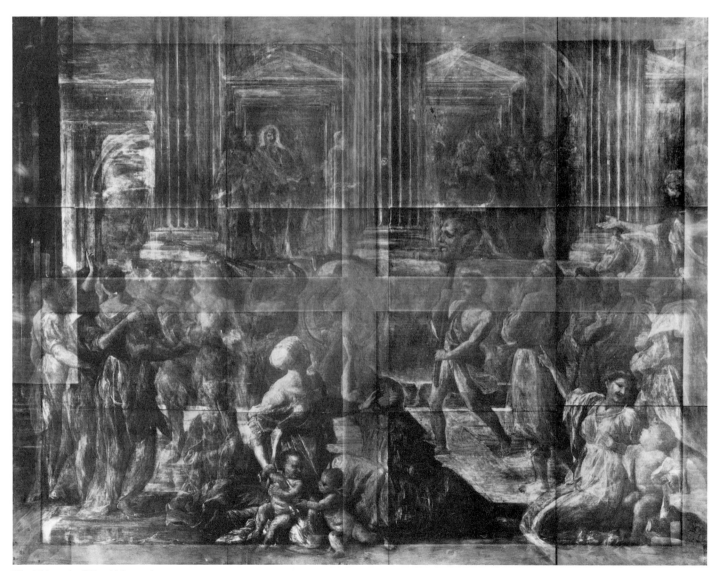

The Triumph of David (no.13)

above left:
Two heads from an Adoration of the Golden Calf (no.3)

above right:
Confirmation (no.35)

right:
Cephalus and Aurora (no.12)

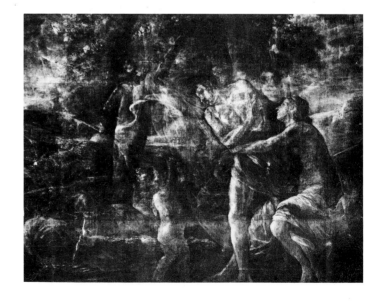

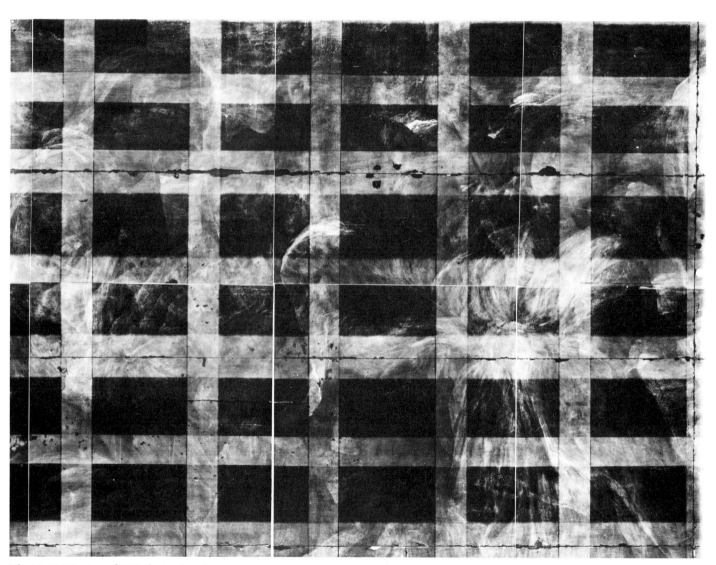

The Mystic Marriage of St Catherine (no.9)

An anthology of Poussin criticism

General References

As for Poussin, the so much Admired Frenchman, his way was in Little for the most part; and some are of Opinion he could not do in Great; or at least, he did not delight in it, having done but two Pieces in all his Life time, that were as big as the Natural; his Figures were generally of two or three Foot long; his Composition Orderly, his Invention Florid; but particularly, he had a Talent for Expressing the PASSIONS: which was most admirable: His Colouring inclines more to the Antique than to Nature. And he has left many Pieces unfinished. But take him altogether in this Way, he is a Great MAN, but not of that first rank of PAINTERS whom all ARTISTS must look upon as the Great Originals that Heaven hath given to Mankind to Imitate; and whose WORKS will not only be the SCHOOL, but the DELIGHT and ADMIRATION of all After Ages, as long as Painting shall retain any Esteem amongst Mankind.

(W. AGLIONBY, *Painting Illustrated in Three Dialogues,* 1685, pp. 125f)

Poussin lived and conversed with the ancient statues so long, that he may be said to have been better acquainted with them, than with the people who were about him. I have often thought that he carried his veneration for them so far as to wish to give his works the air of Ancient Paintings. It is certain he copied some of the Antique Paintings, particularly the Marriage in the Aldobrandini-Palace at Rome, which I believe to be the best relique of those remote ages that has yet been found.

No works of any modern has so much of the air of Antique Painting as those of Poussin. His best performances have a remarkable dryness of manner, which though by no means to be recommended for imitation, yet seems perfectly correspondent to that ancient simplicity which distinguishes his style. Like Polidoro he studied the ancients so much, that he acquired a habit of thinking in their way, and seemed to know perfectly the actions and gestures they would use on every occasion.

Poussin in the latter part of his life changed from his dry manner to one much softer and richer, where there is a greater union between the figures

and the ground; as in the Seven Sacraments in the Duke of Orleans's collection; but neither these, nor any of his other pictures in this manner, are at all comparable to many in his dry manner which we have in England.

The favourite subjects of Poussin were Ancient Fables; and no painter was ever better qualified to paint such subjects, not only from his being eminently skilled in the knowledge of the ceremonies, customs and habits of the Ancients, but from his being so well acquainted with the different characters which those who invented them gave to their allegorical figures. Though Rubens has shewn great fancy in his Satyrs, Silenuses, and Fauns, yet they are not that distinct separate class of beings, which is carefully exhibited by the Ancients, and by Poussin. Certainly when such subjects of antiquity are represented, nothing in the picture ought to remind us of modern times. The mind is thrown back into antiquity, and nothing ought to be introduced that may tend to awaken it from the illusion.

Poussin seemed to think that the style and the language in which such stories are told, is not the worse for preserving some relish of the old way of painting, thrown back into antiquity not only by the subject, but the execution.

(SIR JOSHUA REYNOLDS, *Discourses on Art,* 1769–90, v, ed. R. Wark, 1959, pp.87–8)

The learning of Poussin was not the learning of Nature, not the learning of the refined beauties of form and expression, but the learning of the habits, the customs, the notions of the Ancients – it was the learning of historical research. Homer and Shakespeare were the most learned of all men, that is, in that in which learning is only valuable, Nature. All other learning is a means, a requisite, to set off, adorn, improve, the learning of Nature. Every fault will be excused if that feeling is true, while no learning, no acquirements, no knowledge, will interest if that be deficient.

(*The Diary of Benjamin Robert Haydon* (20 February 1813), ed. W. Pope, 1960, I, pp.292–3)

His human figures are sometimes 'o'er-informed . . . Their actions have too much gesticulation, and the set expression of the features borders too much on the mechanical and caricatured style. In this respect, they form a contrast to Raphael's, whose figures never appear to be sitting for their pictures, or to be conscious of a spectator, or to have come from the painter's hand. In Nicolas Poussin, on the contrary, every thing seems to have a distinct understanding with the artist: 'the very stones prate of their whereabouts': each object has its part and place assigned, and is in a sort of

compact with the rest of the picture. It is this conscious keeping, and, as it were, *internal* design, that gives their peculiar character to the works of our artist . . . Poussin succeeded better in classic than in sacred subjects. The latter are comparatively heavy, forced, full of violent contrasts of colour, of red, blue, and black, and without the true prophetic inspiration of the characters. But in his Pagan allegories and fables he was quite at home. The native gravity and native levity of the Frenchman were combined with Italian scenery and an antique gusto, and gave even to his colouring an air of learned indifference. He wants, in one respect, grace, form, expression; but he has everywhere sense and meaning, perfect costume and propriety. His personages always belong to the class and time represented, and are strictly versed in the business in hand. His grotesque compositions in particular, his Nymphs and Fauns, are superior (at least, as far as style is concerned) even to those of Rubens. They are taken more immediately out of fabulous history. Rubens's Satyrs and Bacchantes have a more jovial and voluptuous aspect, are more drunk with pleasure, more full of animal spirits and riotous impulses; they laugh and bound along –

'Leaping like wanton kinds in pleasant spring:'

but those of Poussin have more of the intellectual part of the character, and seem vicious on reflection, and of set purpose. Rubens's are noble specimens of a class; Poussin's are allegorical abstractions of the same class, with bodies less pampered, but with minds more secretly depraved . . . But, above all, who shall celebrate, in terms of fit praise, his picture of the shepherds in the Vale of Tempe going out in a fine morning of the spring, and coming to a tomb with this inscription: Et Ego in Arcadia Vixi! The eager curiosity of some, the expression of others who start back with fear and surprise, the clear breeze playing with the branches of the shadowing trees, 'the valleys low, where the mild zephyrs use', the distant, uninterrupted, sunny prospect speak (and for ever will speak on) of ages past to ages yet to come!

(W. HAZLITT, On a landscape of Nicholas Poussin. *Table Talk; or Original Essays,* 1821–2. *Complete Works,* ed. P. Howe, 1931, VIII, pp.171–3)

Such was his attachment to the ancients, that it may fairly be said he less imitated their spirit than copied their relics and painted sculpture; the costume, the mythology, the rites of antiquity were his element; his scenery, his landscape, are pure classic ground. He has left specimens to show that he was sometimes sublime, and often in the highest degree pathetic, but history in the strictest sense was his property, and in that he ought to be followed. His agents only appear to tell the fact; they are subordinate to the story. Sometimes he attempted to tell a story that cannot be told: of his historic dignity the celebrated series of Sacraments; of his sublimity, the vision he gave to Coriolanus; of his pathetic power, the infant Pyrrhus; and of the vain attempt to tell by figures what words alone

can tell, the testament of Eudamidas are striking instances. His eye, though impressed with the tint, and breadth and imitation of Titian, seldom inspired him to charm with colour; crudity and patches frequently deform his effects.

(H. FUSELI, Art of the Moderns. *Lectures on Painting by the Royal Academicians,* ed. R. Wornum, 1889, p.391)

It would take considerable time to enter into accurate analysis of Poussin's strong but degraded mind; and bring us no reward, because whatever he has done has been done better by Titian. His peculiarities are, without exception, weaknesses, induced in a highly intellectual and inventive mind by being fed on medals, books, and bassi-relievi instead of nature, and by the want of any deep sensibility. His best works are his Bacchanalian revels, always brightly wanton and wild, full of frisk and fire; but they are coarser than Titian's, and infinitely less beautiful. In all minglings of the human and brutal character he leans on the bestial, yet with a sternly Greek severity of treatment. This restraint, peculiarly classical, is much too manifest in him; for, owing to his habit of never letting himself be free he does nothing as well as it ought to be done, rarely even as well as he can himself do it; and his best beauty is poor, incomplete, and characterless, though refined.

(JOHN RUSKIN, *Modern Painters,* Part IX, V, 1860. *Complete Works,* ed. E. Cook and A. Wedderburn, VII, 1905, pp.322–3)

I think there can be no doubt that Poussin believed, as the Academicians who based themselves upon his practice, later believed, that such an abstracted and generalized art was in some way connected with a peculiarly elevated moral tone. None the less, when once he got to work his intense feeling for formal harmonies became his chief preoccupation, as indeed it remains for us, now that we no longer respond to the rhetoric of Poussin's time, the real meaning of his work.

(R. FRY, *Characteristics of French Art,* 1932, p.30)

Sacraments

Second series

In 1665 Bernini visited Paris at the invitation of Louis XIV. Chantelou, then Maître d'Hotel to the King was appointed to assist Bernini during his stay. Some years after he wrote a journal of this visit. The following extract described a visit Bernini paid to Chantelou's house to see his collection and his comments on Poussin's Sacraments:

I next uncovered the 'Marriage'. Having drawn aside the curtain where it concealed part of a figure behind a column, he scrutinised this picture in silence as he had done the first. After a while he said 'It is Saint Joseph and the Virgin'. The priest, he added, was not dressed as a priest. I replied that this was before the establishment of our religion. He rejoined that nevertheless there were high priests in Judaism. They then remarked in admiration upon the grandeur and majesty of the picture, and studied the whole effect with the greatest attention. Coming to details, they admired the nobility and reverence of the girls and women who are introduced into the ceremony, most of all the one who is half behind a column.

(Manuscript first published by L. Lalanne in *Gazette des Beaux-Arts,* XVI, 1877, pp.177–9. Translation by C. Cornford, reprinted from exhibition catalogue, *Nicolas Poussin, The Seven Sacraments,* Hatton Gallery, Newcastle upon Tyne, 1951, p.12)

Second series

In this manner did Pallet proceed with an external rotation of tongue, floundering from one mistake to another, until it was the turn of Poussin's seven sacraments to be examined. Here again the Swiss out of the abundance of his zeal, expressed his admiration, by saying, these pieces were *impayable*; when the painter turning to him with an air of exultation, 'Pardon me, friend, there you happen to be mistaken, these are none of *impayable's,* but done by Nicholas Pousseen. I have seen prints of them in England, so that none of your tricks upon travellers, Mr Swish or Swash, or what's your name'.

(TOBIAS SMOLLET, *The Adventures of Peregrine Pickle,* II, 1751, chapter XLVI, p.64. The episode takes place in the apartments of the Palais Royal and the description of these pictures as *impayable* may reflect the reputation they acquired after the Duke of Marlborough tried to buy them for 50,000 Crowns and was refused (cf. PIERRE JEAN BAPTISTE NOUGARET, *Anecdotes des beaux-arts,* II, Paris, 1776, p.128))

First series

The Sacraments; in which there is much Variety, as to their Manner; some of them have at first Sight a great Air of Copies, Others are much better

55a

Painted. None of them are well Colour'd, tho' Some better than Others; without doubt they were Raw at first: They are in General Laboriously done. But what makes amends for all their Defects is, they are finely Thought, and the Expression throughout Admirable; in which respects I think they are better than those the Regent has, and consequently are preferrable to His, whatever Disadvantage they may Otherwise have in the Comparison.

The Baptism has no good *Clair-Obscure,* but is remarkable for the Expressions of Surprize, and Devotion upon the Sight of the Dove.

The Communion, or *Lectisternium,* has excellent Airs of Heads, and Actions; but has more of the Air of a Copy than any of them, tho' 'tis undoubtedly not so.

That of Marriage; and That of Extreme Unction, are chiefly remarkable for the fine Airs.

That of Confirmation is best Painted of them all; there is a Bold Pencil seen, and better colouring than in any other of them.

(J. RICHARDSON, *An Account of some of the statues, bas-reliefs, drawings and pictures in Italy . . .,* 1722, pp.188–9)

First series
I went t'other day when I was in town to see the Sacraments of Poussin that he [James Byres] has purchased from Rome for the Duke of Rutland. I remember when I saw them there a thousand years ago that I was not much enchanted – I rather like them better now than I expected, at least two or three of them – but they are really only coloured bas-reliefs, and old Romans don't make good Christians.

(Letter from Horace Walpole to Lady Ossory, Strawberry Hill, 1 December 1786. *The Yale Edition of Horace Walpole's Correspondence,* ed. W. S. Lewis, XXX (2), 1965, pp.538–9)

Second series
The year 1644 was chiefly employed upon the second series of the Sacraments: and never, perhaps, were the mysteries of religion set forth with greater dignity and solemnity than in these pictures. The mind of Poussin was truly devout, and he felt sincerely the importance of the subjects he painted. Hence the grave and expressive character of these pictures, particularly of the Extreme Unction, which was the first finished, and sent to Paris early in 1645, and was soon followed by the rest; of which

it was observed, that the Marriage was the most feeble, and gave occasion for the Parisian wits to say, that it was difficult to make a good matrimonial scheme, even in painting.

(MARIA GRAHAM, *Memoirs of the Life of Nicholas Poussin,* 1820, pp.113–14)

Second series
The Sacraments, by N. Poussin, occupy a separate room by themselves, and have a grand and solemn effect; but we could hardly see them where they are; and in general, we prefer his treatment of light and classical subjects to those of sacred history. He wanted *weight* for the last; or, if that word is objected to, we will change it, and say *force*.

(W. HAZLITT, *Criticism on art, with catalogues of the principal galleries of England,* 1844 (The Marquis of Stafford's Gallery). *Complete Works,* ed. P. Howe, 1931, VIII, p.36)

Works cited in an abbreviated form

Bellori
 G. P. Bellori, *Le vite de pittori* . . ., Rome, 1672 (ed. E. Borea and
 G. Previtali, Turin, 1976)
Blunt 1966
 A. Blunt, *The Paintings of Nicolas Poussin. A Critical Catalogue,* London,
 1966
Blunt 1967
 A. Blunt, *Nicolas Poussin,* London, 1967, 2 vols
Blunt, *Drawings*
 A. Blunt, *The Drawings of Poussin,* New Haven and London, 1979
Blunt, *French Drawings*
 A. Blunt, *The French Drawings* . . . *at Windsor Castle,* London, 1945
CR
 W. Friedlaender and A. Blunt, *The Drawings of Poussin. Catalogue
 Raisonné,* London, 1939–74, 5 vols
Félibien
 A. Félibien, *Entretiens sur les vies et sur les ouvrages des plus excellens peintres*
 . . ., Paris, 1725, 6 vols
Friedlaender
 W. Friedlaender, *Nicolas Poussin,* London, 1966
Thompson
 C. Thompson, *Poussin's Seven Sacraments in Edinburgh,* (W. A. Cargill
 Memorial Lectures in Fine Art), Glasgow, 1980
Thuillier
 J. Thuillier, *Tout l'œuvre peint de Poussin,* Paris, 1974

Exhibitions

Bologna 1962
L'ideale classico del Seicento in Italia e la pittura di paesaggio. Bologna, Palazzo dell'Archiginnasio, 1962 (entries on Poussin by D. Mahon)

Newcastle 1951/2
Introduction to Poussin; and *Nicolas Poussin. The Seven Sacraments.* Catalogues by R. Holland of two exhibitions at the Hatton Gallery, Newcastle upon Tyne, 1951/2

Paris 1960
Nicolas Poussin. Catalogue by A. Blunt and C. Sterling. Musée du Louvre, Paris, 1960

Rome 1977–8
Nicolas Poussin. Catalogue by P. Rosenberg, J. Thuillier, and A. Blunt. Villa Medici, Rome, 1977–8

Rouen 1961
Nicolas Poussin et son Temps. Catalogue by P. Rosenberg. Musée des Beaux-Arts, Rouen, 1961

List of lenders

HM Queen Elizabeth II 16, 19, 21, 22, 23, 36, 42, 46, 58, 59
His Grace the Duke of Rutland 31, 32, 33, 34, 35
His Grace the Duke of Sutherland 28, 40, 41, 47, 52, 53, 54, 55

Anonymous loans 1, 3, 57, 61
Birmingham, Barber Institute of Fine Arts, the University 14
Chatsworth (Derbyshire), the Trustees of the Chatsworth Settlement 5
Cleveland, Museum of Art 10
Dublin, National Gallery of Ireland 7
Florence, Gabinetto Disegni e Stampe degli Uffizi 20, 60
Kansas City, Nelson Gallery–Atkins Museum 24, 25
London, British Museum 17, 39, 56
London, Dulwich Picture Gallery 8, 13
London, National Gallery 12, 15, 26
Madrid, the Prado 11
Montpellier, Musée Fabre 2
Newcastle upon Tyne, Department of Fine Art, the University 62
Paris, Ecole des Beaux-Arts 38
Paris, Musée du Louvre, Cabinet des Dessins 29, 43, 44, 45, 48, 49, 50, 51
Paris, Musée du Louvre, Department of Paintings 4, 30
Philadelphia, Museum of Art 27
Sudeley Castle, the Trustees of the Walter Morrison Pictures Settlement 18
Washington, National Gallery of Art 37